Masterpieces of

Metsu

(1912)

ISBN-13 : 978-1512336979
ISBN-10 : 1512336971

Copyright©2012-2014 Iacob Adrian
All Rights Reserved.

Notice

This documentary study use historic, archived documents.

Because of this, some pages may look blurry or low quality.

Still are included in this book because they have

high value from critical, documentary, historical,

informative and journalistic point of view .

Dtp and visual art

Iacob Adrian

THE
MASTERPIECES
OF
METSU
(1630 (?) -1667)

Sixty reproductions of photographs from the original paintings, affording examples of the different characteristics of the Artist's work

Author statement

This is a series of art books .

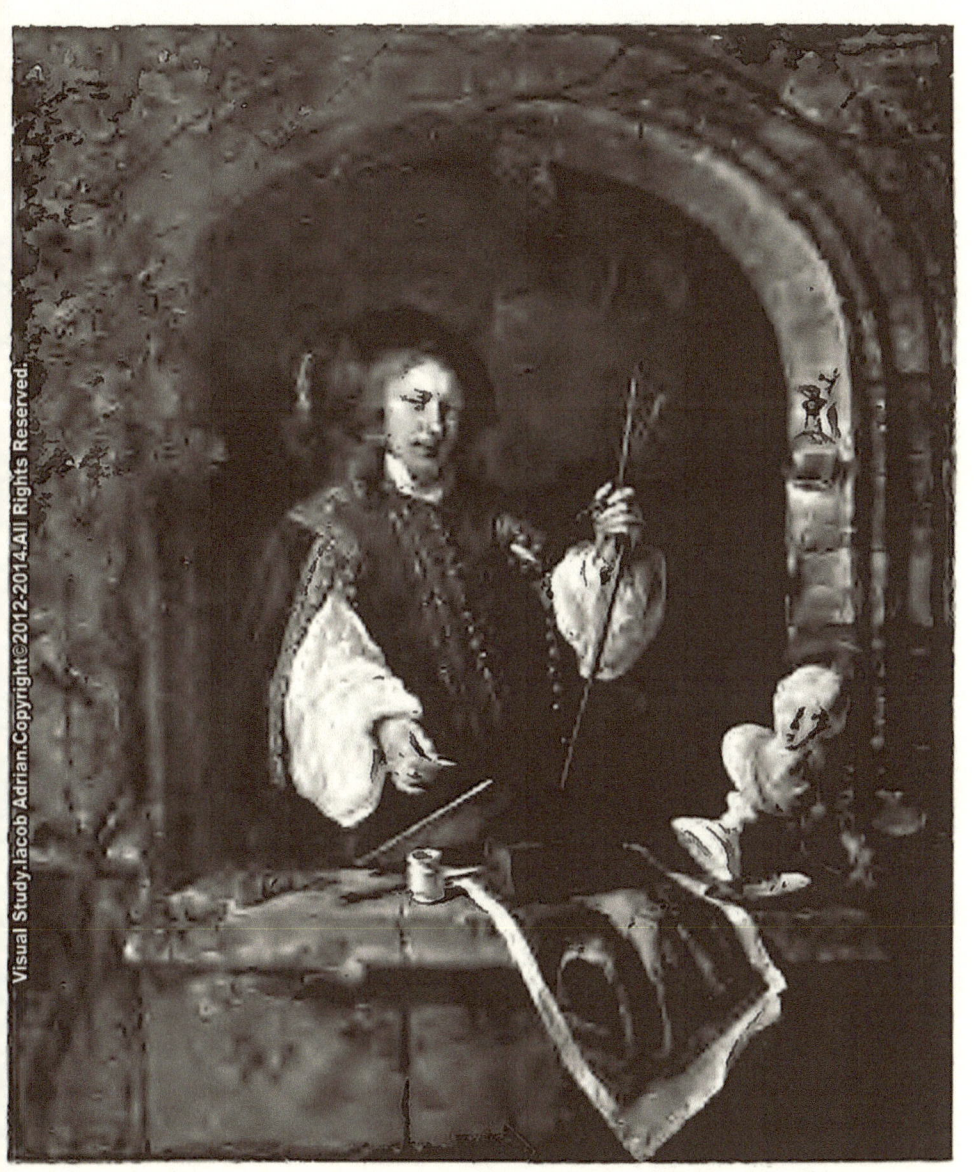

PORTRAIT OF HIMSELF [208] PORTRAIT DE L'ARTISTE
SELBSTBILDNIS
(Buckingham Palace, London)
F. Hanfstaengl, Photo.

This little Book conveys the greetings of

...

to

...

―――――――――――――――――

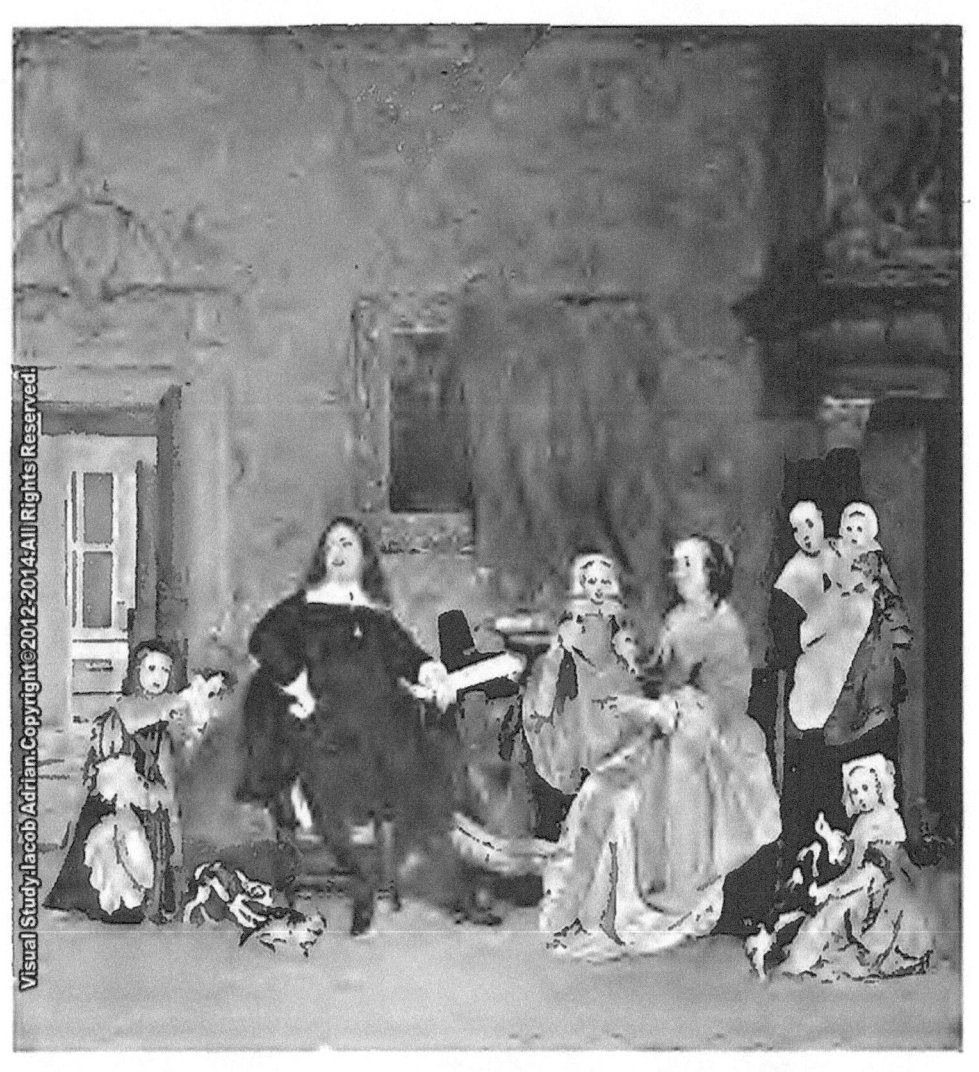

[243]
THE FAMILY OF THE MERCHANT LA FAMILLE DU MARCHAND
GEELVINCK GEELVINCK
DIE FAMILIE DES KAUFMANNS GEELVINCK
(*Kaiser Friedrich-Museum, Berlin*)
F. Hanfstaengl, Photo.

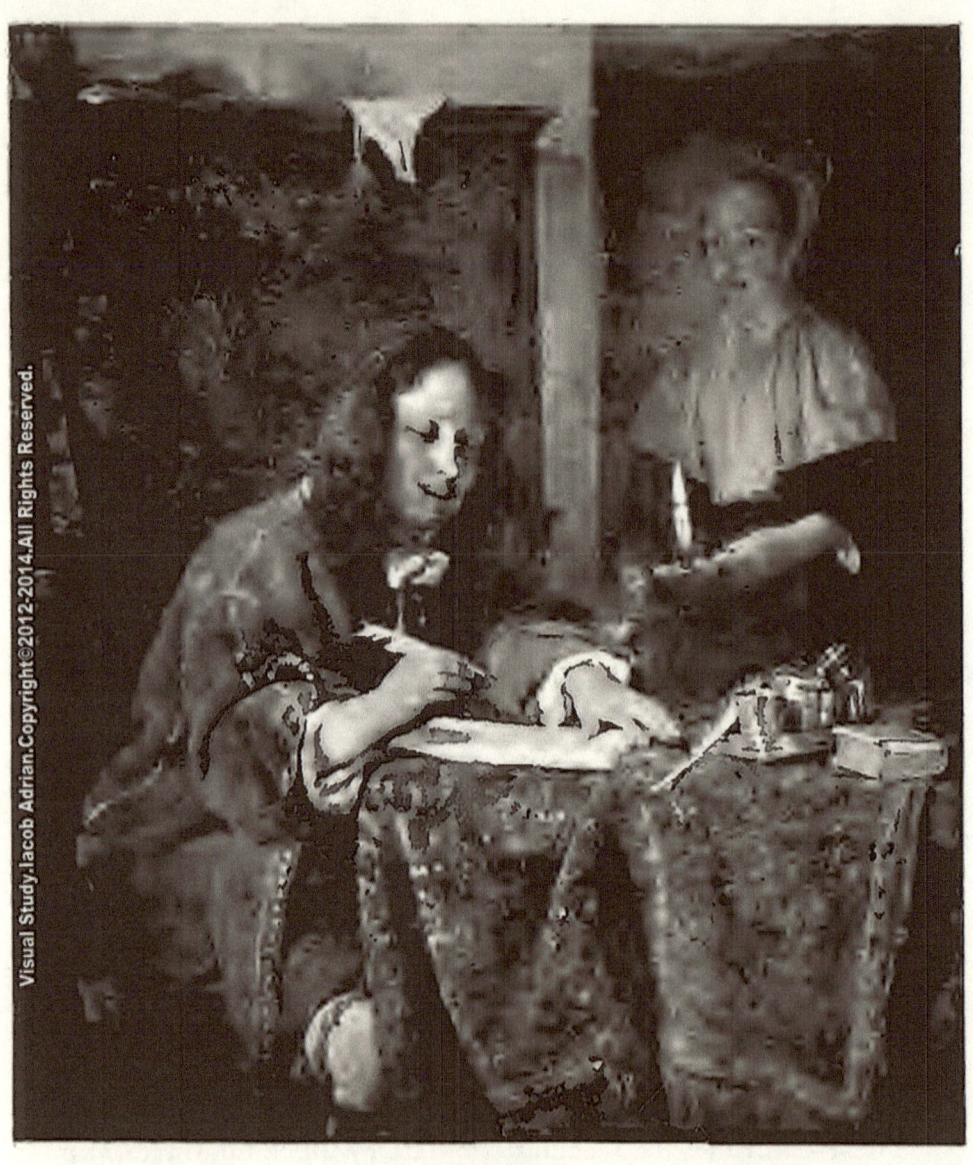

MAN WRITING [24] HOMME ÉCRIVANT
SCHREIBENDER MANN
(Musée, Montpellier)
W. A. Mansell & Co., Photo.

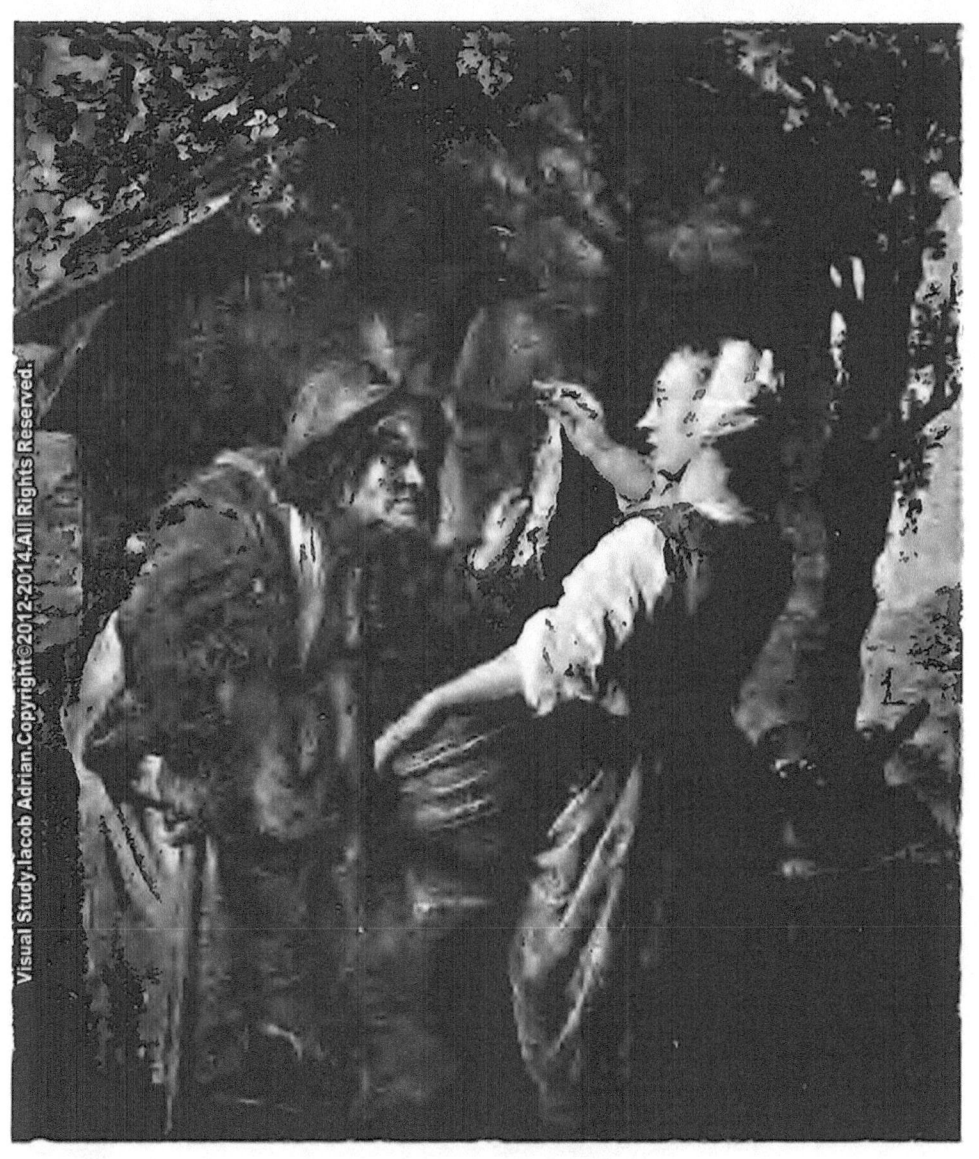

THE HERRING-WOMAN [32] LA VENDEUSE DE HARENGS
DIE HERINGSVERKÄUFERIN
(Dr. J. Six, Amsterdam)
Medici-Bruckmann, Photo.

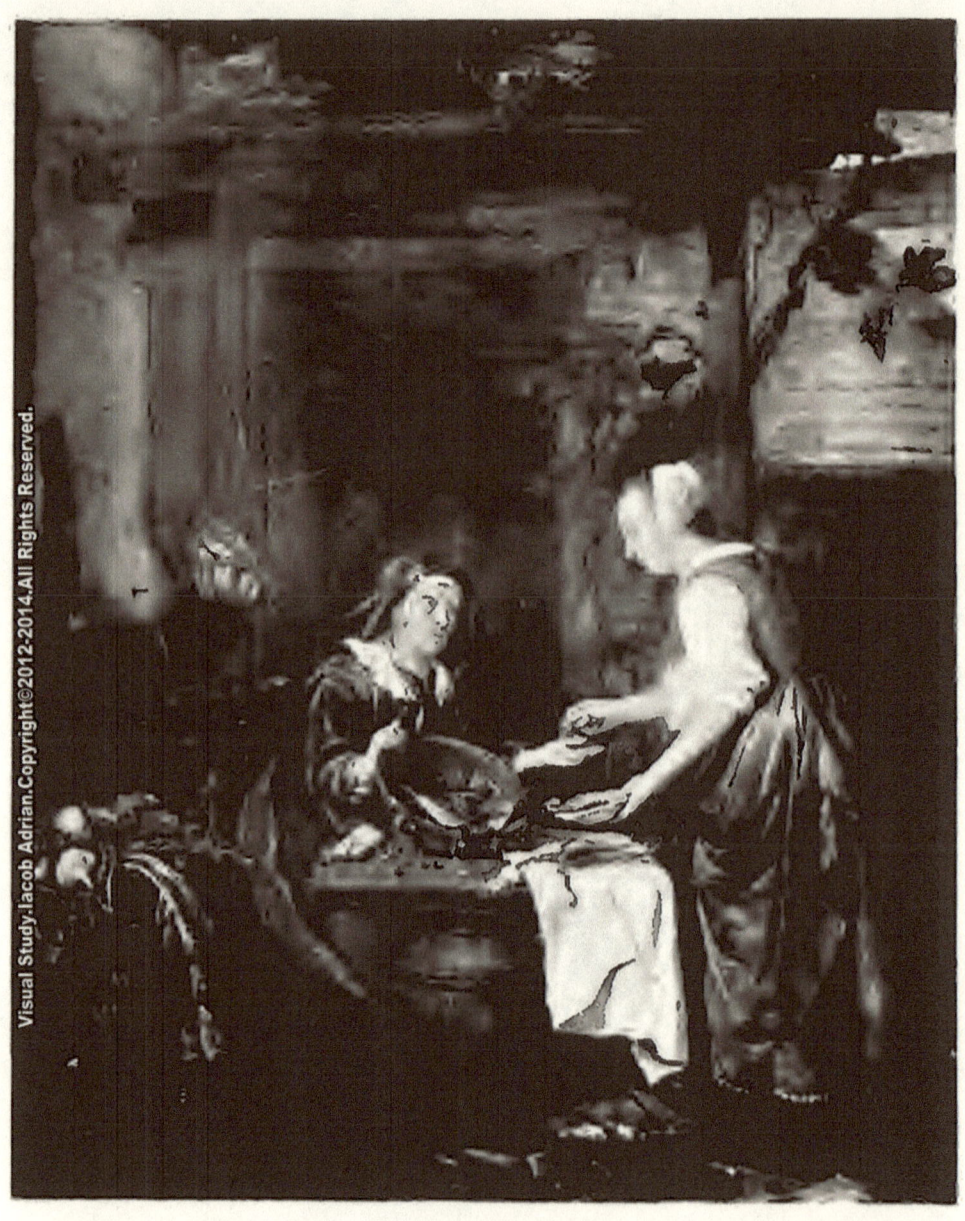

Old Woman selling Fish [33] Vieille Femme vendant du Poisson
Alte Fischverkäuferin
(Wallace Collection, London)
W. A. Mansell & Co., Photo.

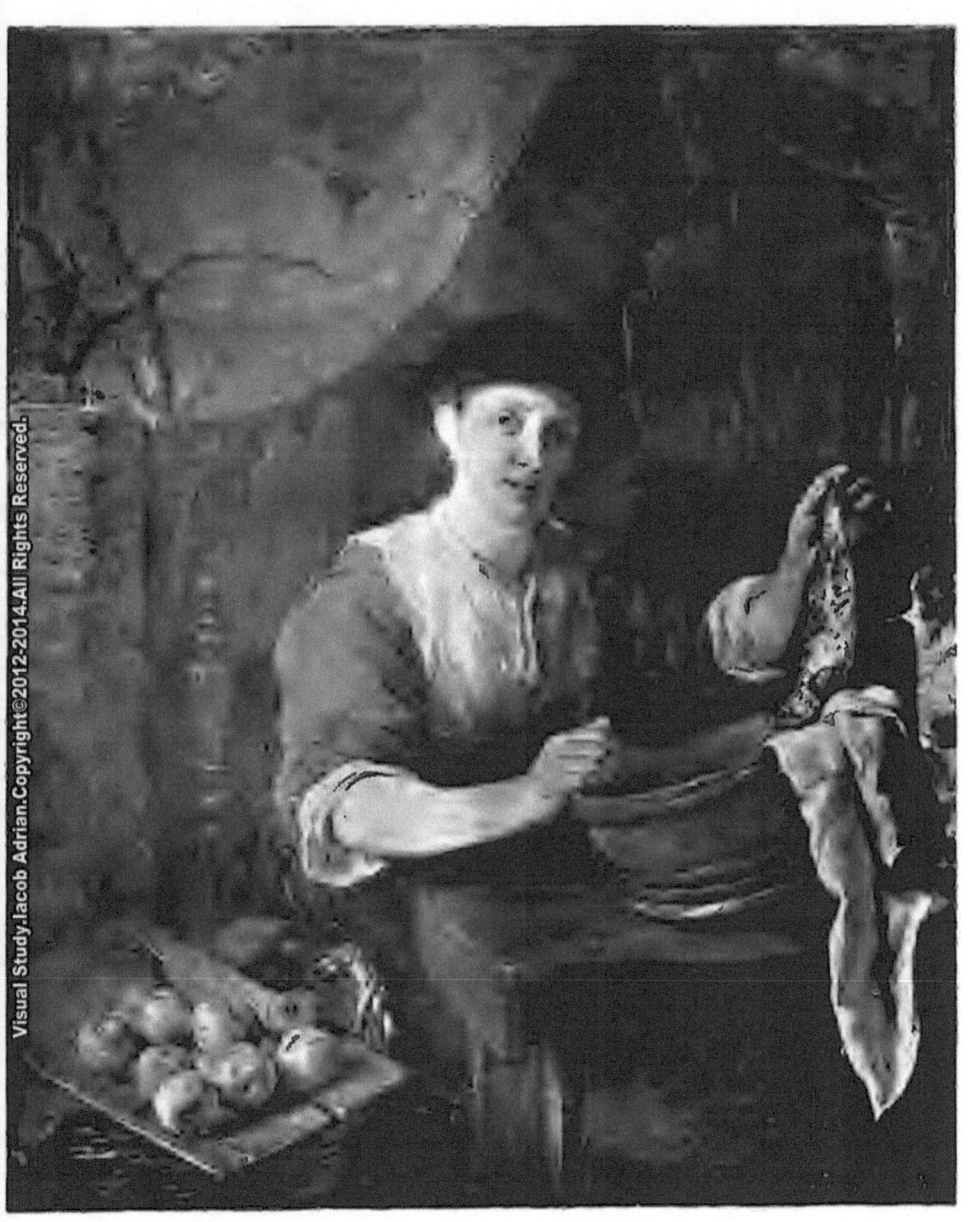

[34]
WOMAN SELLING HERRINGS FEMME VENDANT DES HARENGS
HERINGSVERKÄUFERIN
(*Earl of Ellesmere, London*)
Walter L. Bourke, Photo.

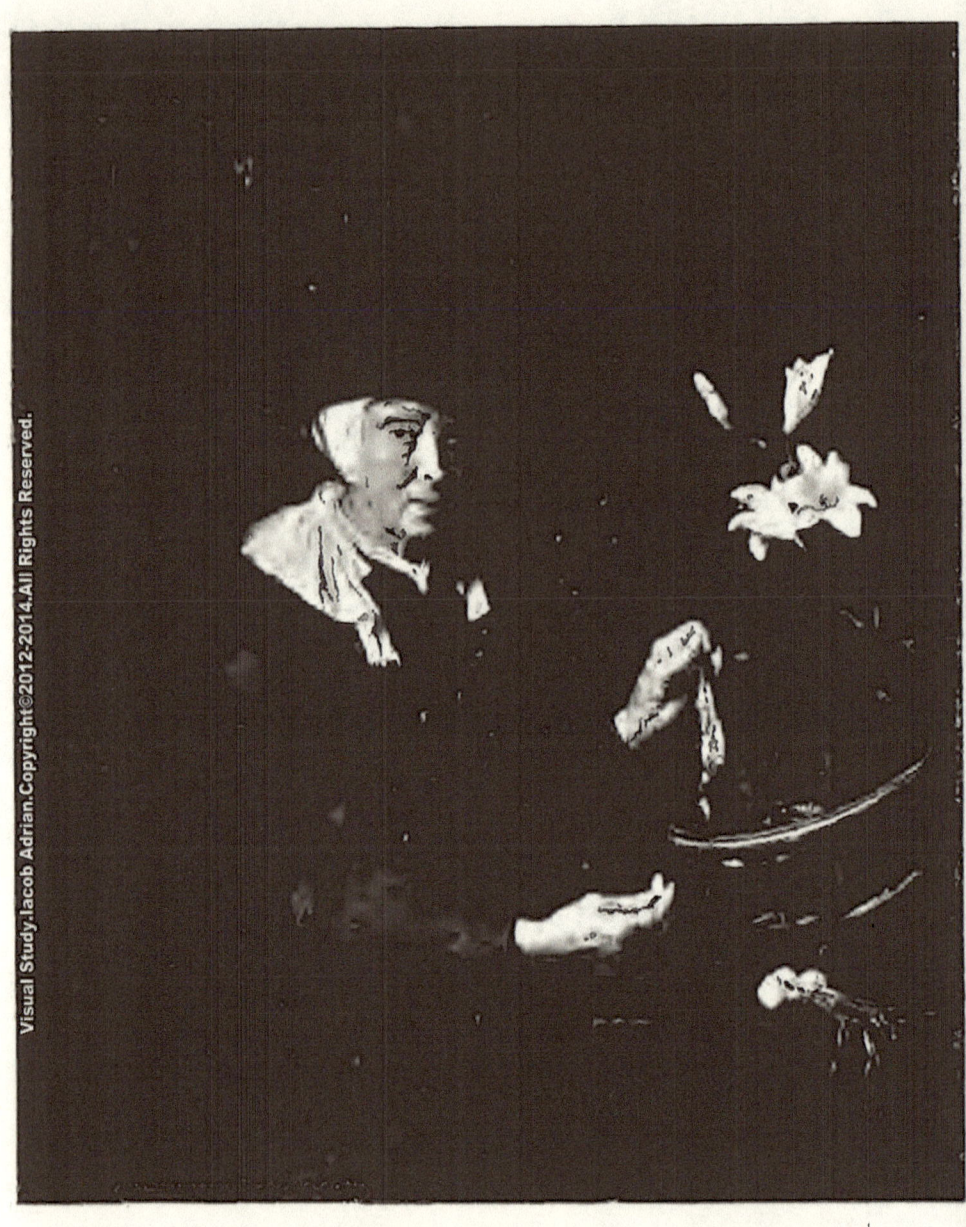

OLD WOMAN SELLING FISH [35] VIEILLE FEMME VENDANT DU POISSON
ALTE FISCHVERKÄUFERIN
(*Musée, Montpellier*)
W. A. Mansell & Co., Photo.

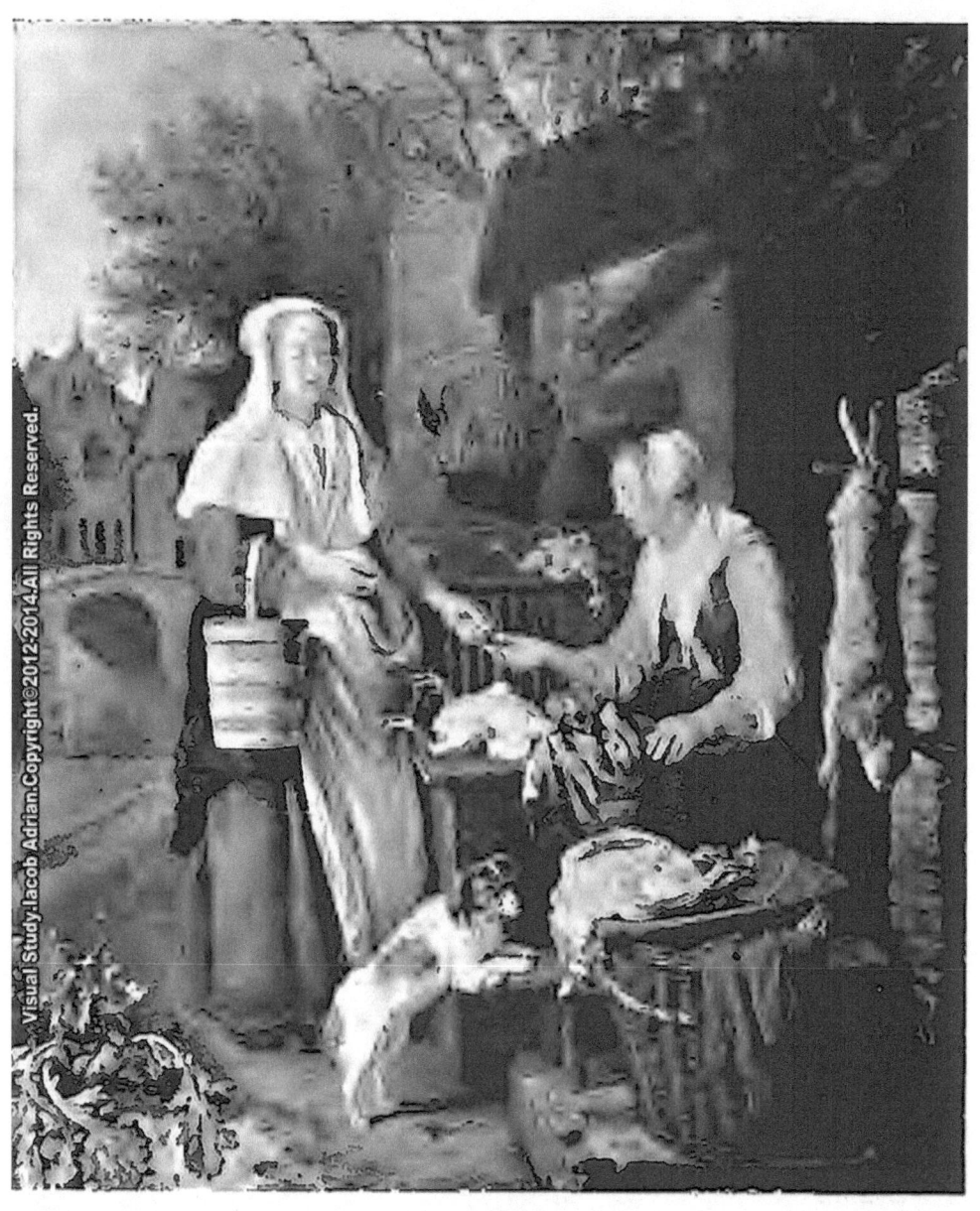

[42]
THE POULTRY DEALER LA MARCHANDE DE VOLAILLE
DIE GEFLÜGELHÄNDLERIN
(*Kassel, Galerie*)
F. Hanfstaengl, Photo.

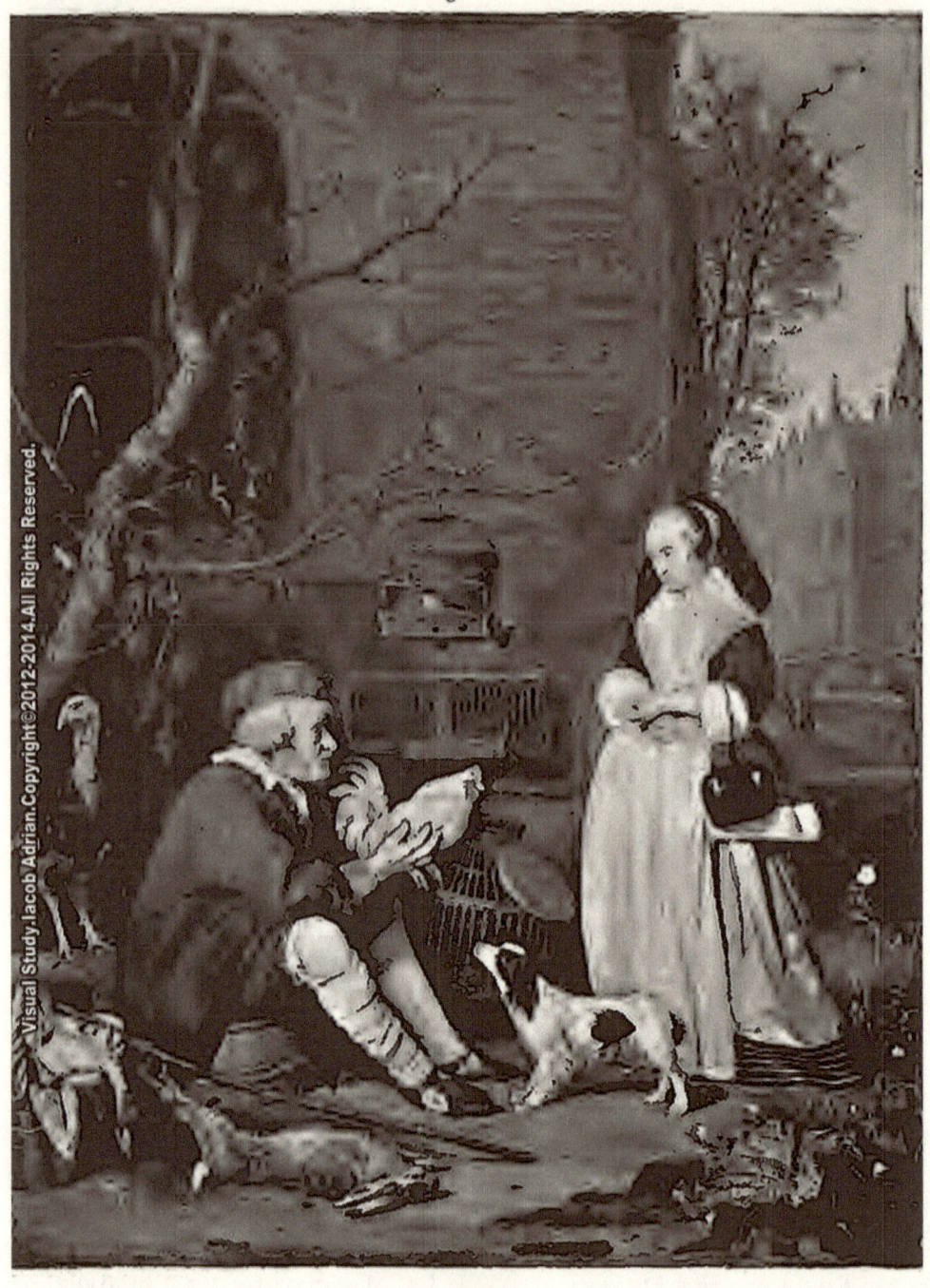

[43]
MAN SELLING POULTRY HOMME VENDANT DE LA VOLAILLE
DER GEFLÜGELVERKÄUFER
(*Dresden, Galerie*)
F. Hanfstaengl, Photo.

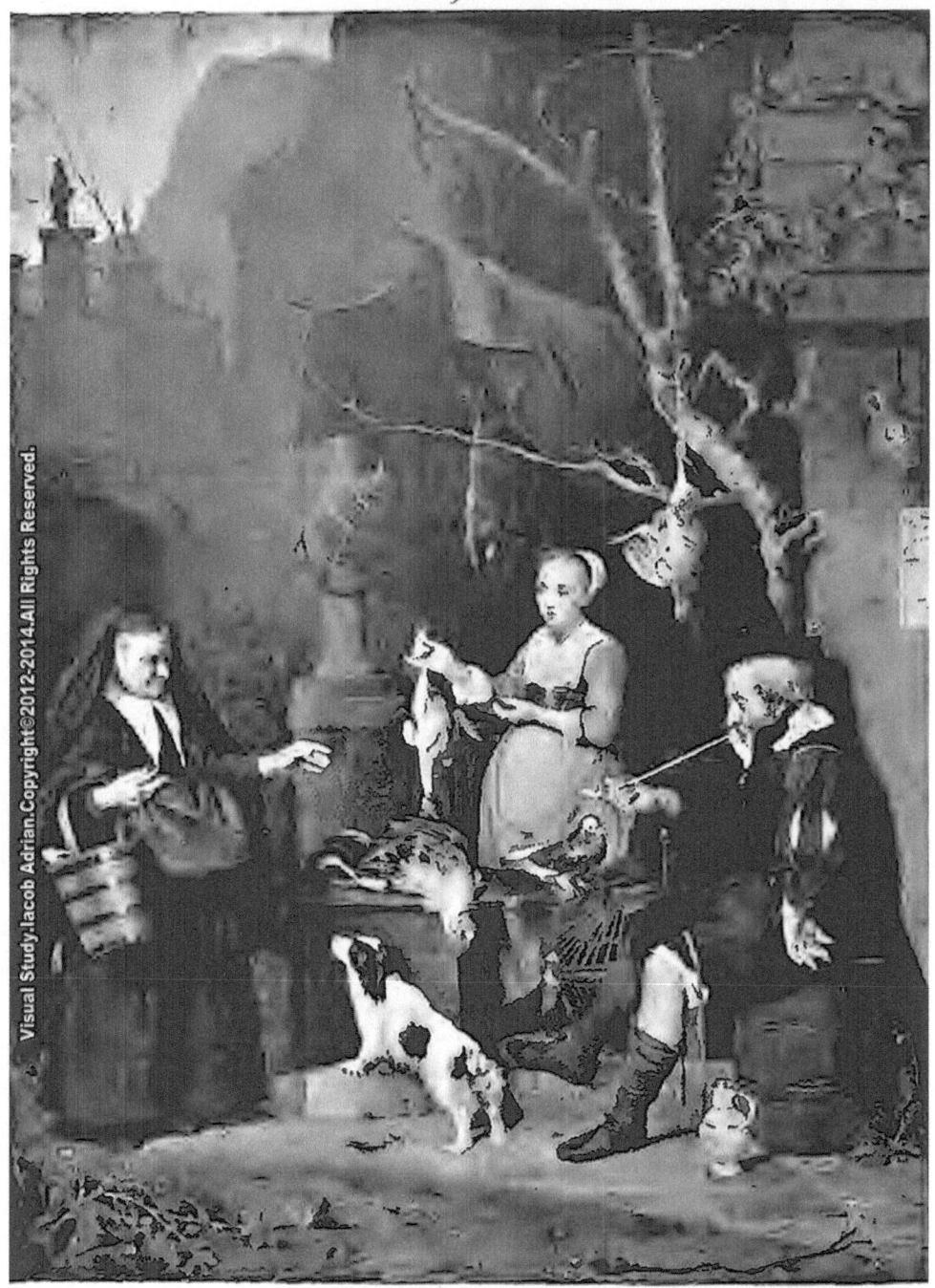

[44]
WOMAN SELLING POULTRY FEMME VENDANT DE LA VOLAILLE
DIE GEFLÜGELVERKÄUFERIN
(*Dresden, Galerie*)
F. Hanfstaengl, Photo.

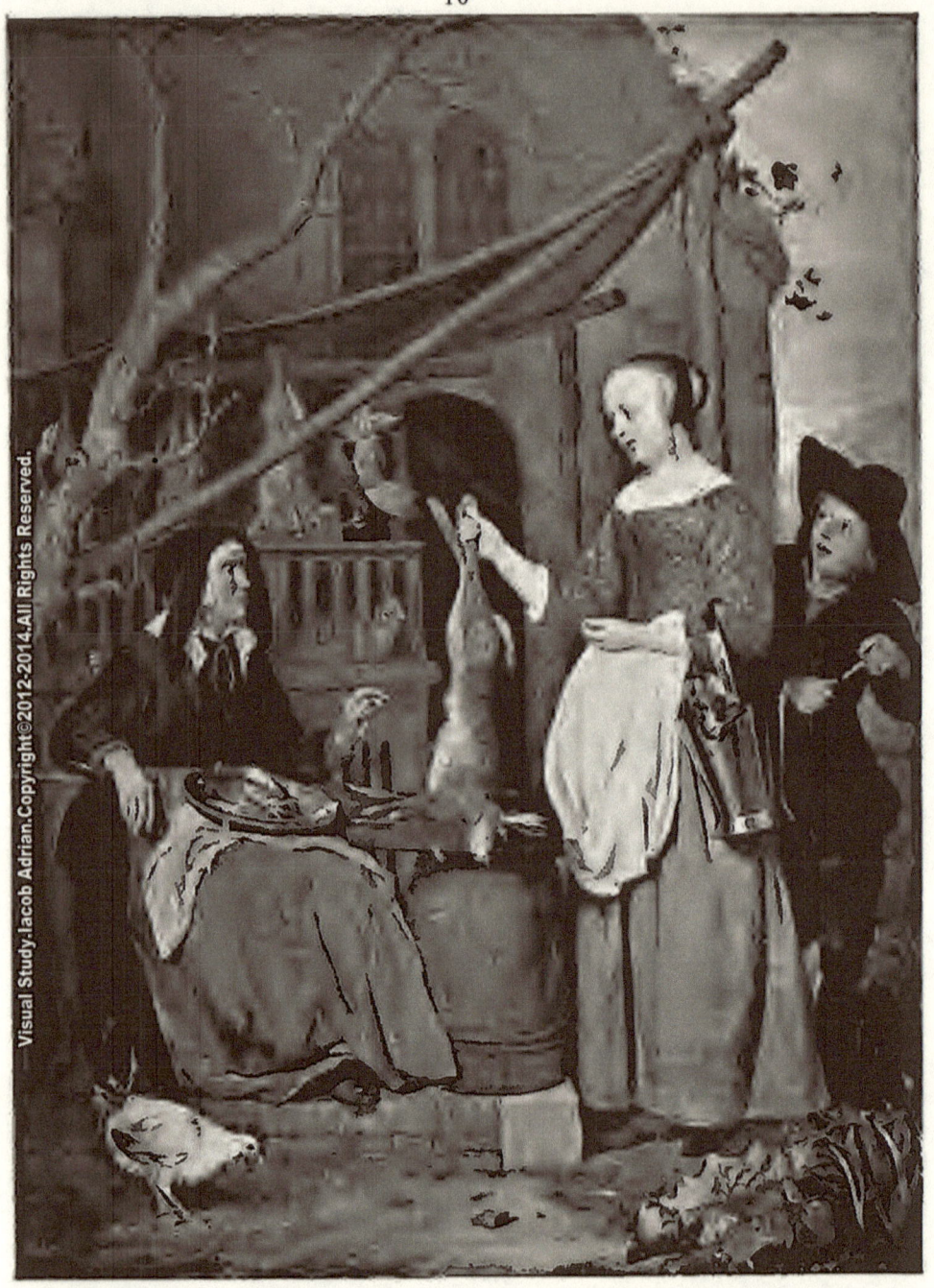

Old Woman selling Game [45] Vieille Femme vendant du Gibier

Die alte Wildhändlerin
(*Dresden, Galerie*)
F. Hanfstaengl, Photo.

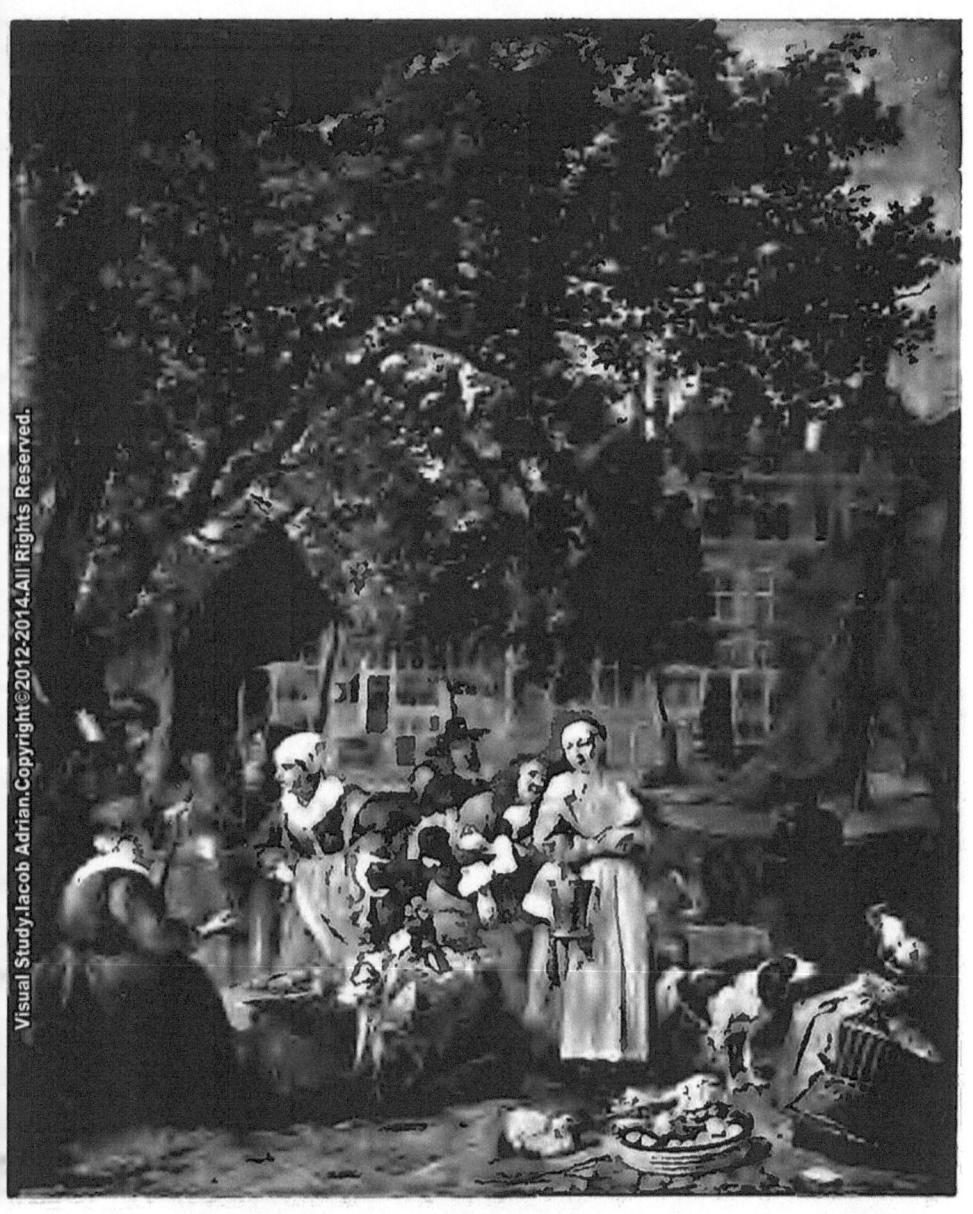

THE VEGETABLE MARKET [49] LE MARCHÉ AUX HERBES
AT AMSTERDAM D'AMSTERDAM
DER GEMÜSEMARKT ZU AMSTERDAM
(*Louvre, Paris*)
F*rat. Alinari, Photo.*

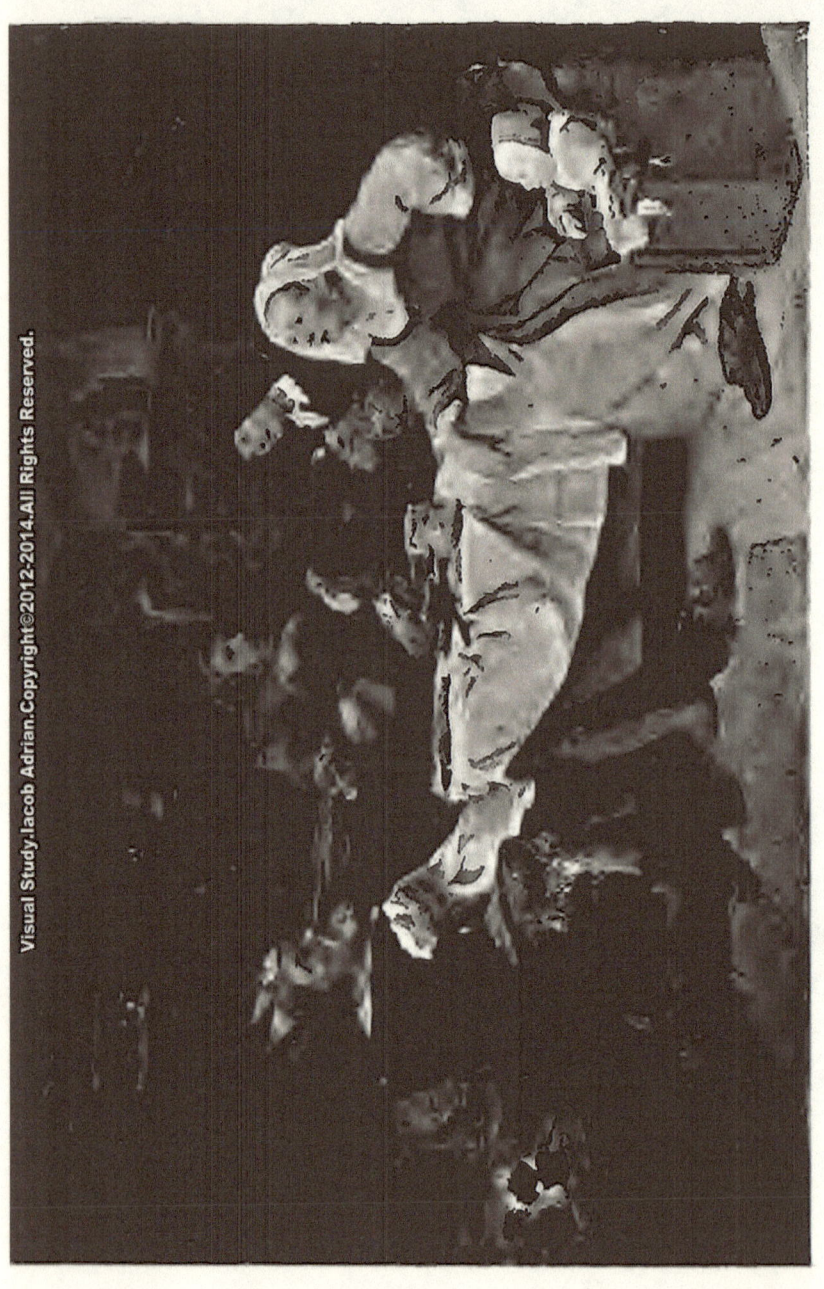

[58]

TWELFTH-NIGHT DREIKÖNIGSFEST LE JOUR DES ROIS
(*Pinacotheca, Munich*) (*München, Pinakothek*) (*Pinacothèque, Munich*)
F. Hanfstaengl, *Photo.*

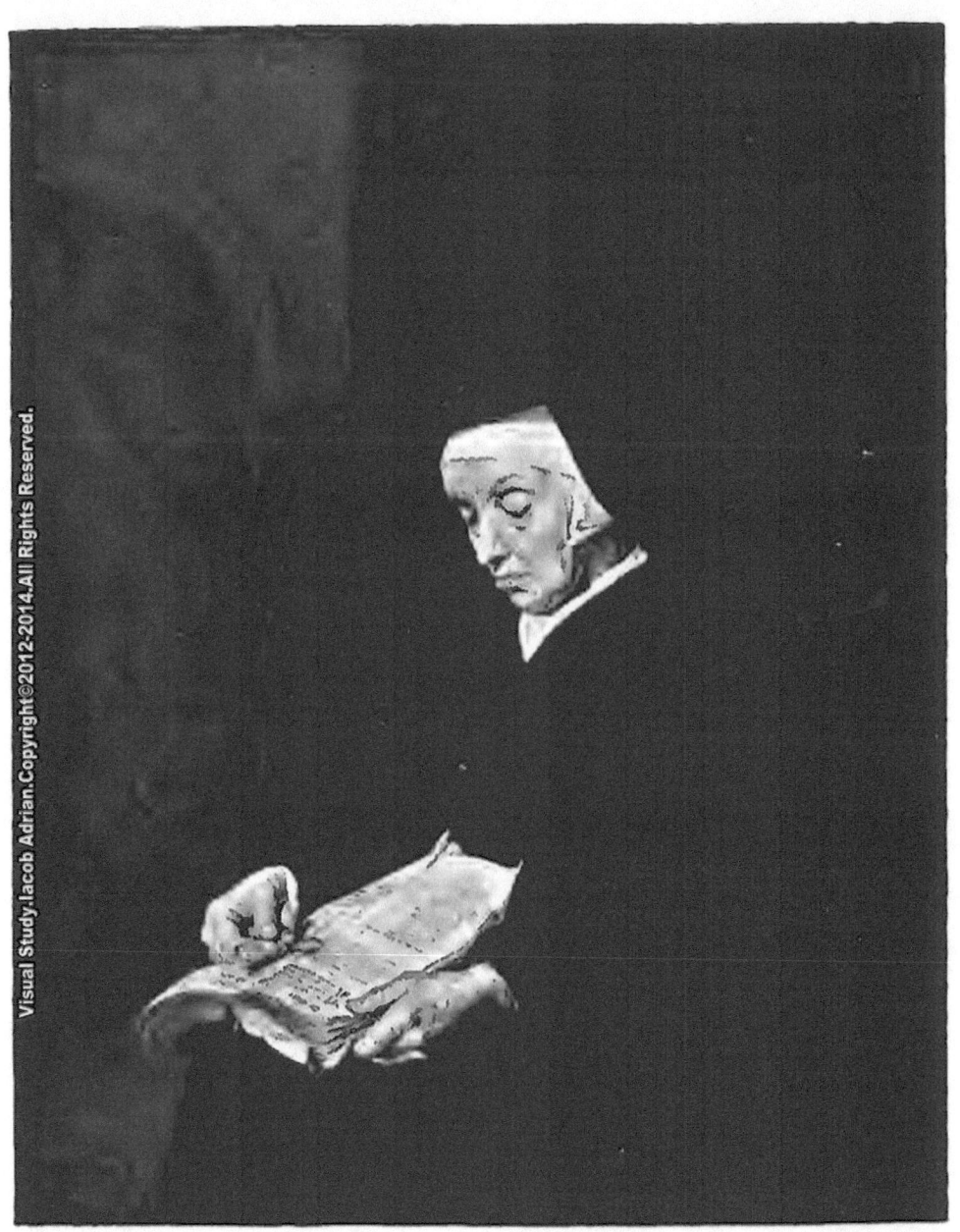

OLD WOMAN READING [68] VIEILLE FEMME LISANT
LESENDE ALTE FRAU
(*Rijksmuseum, Amsterdam*)
F. Hanfstaengl, Photo.

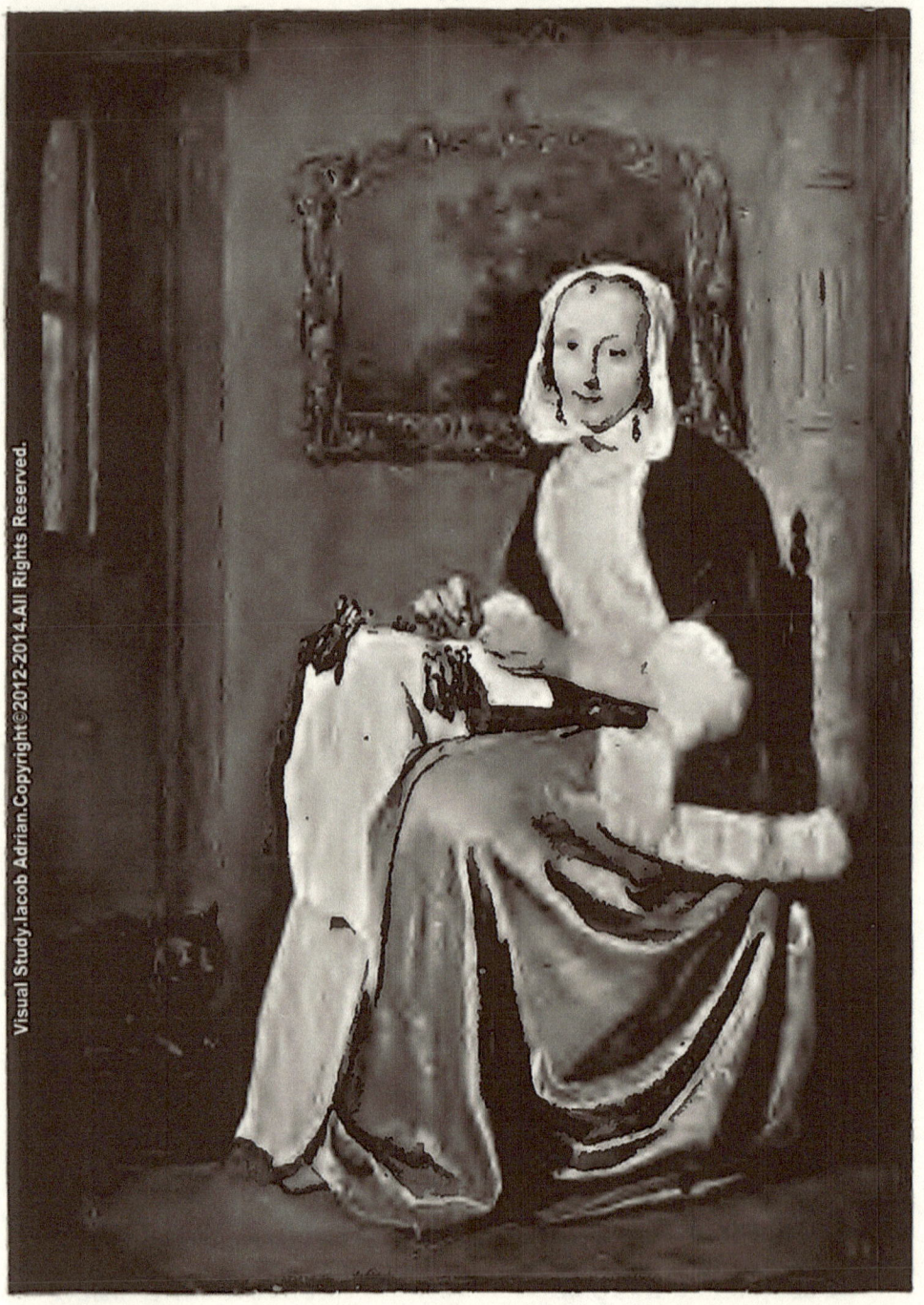

THE LACE-MAKER [79] LA DENTELLIÈRE
DIE SPITZENKLÖPPLERIN
(*Dresden, Galerie*)
F. Hanfstaengl, Photo.

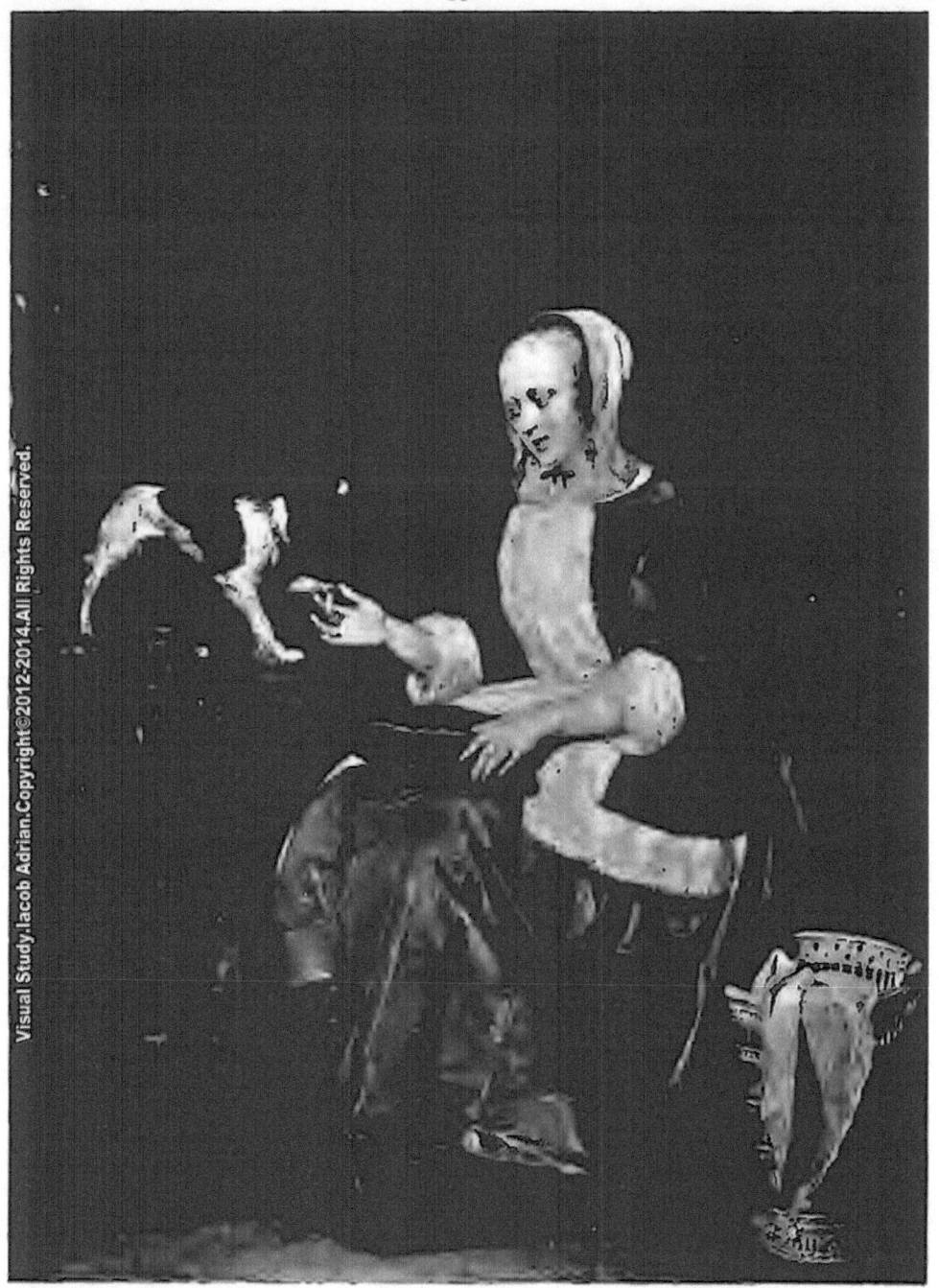

LADY WITH DOG [95] DAME AVEC CHIEN
DAME MIT HUND
(*Earl of Ellesmere, London*)
Walter L. Bourke, Photo.

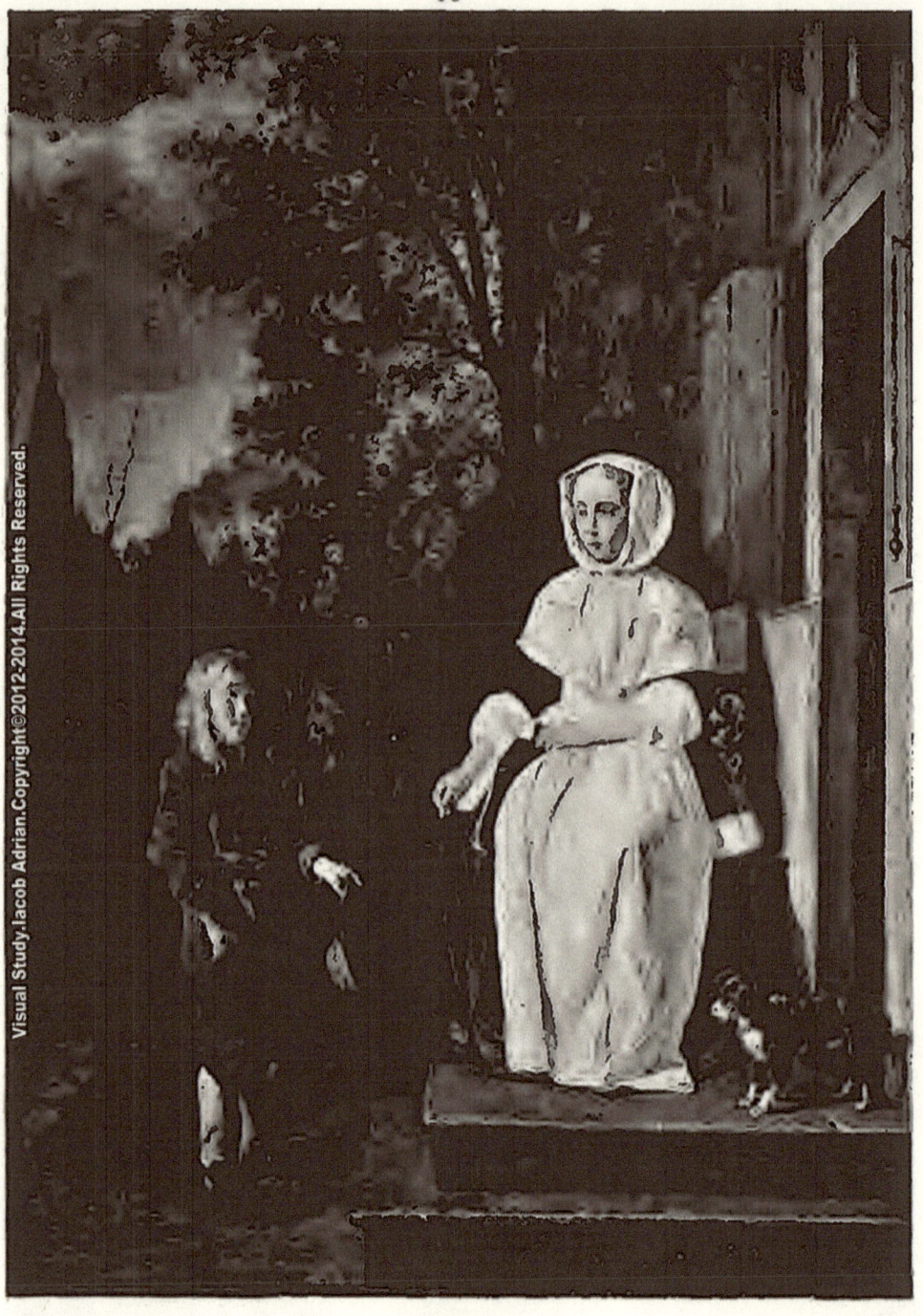

[109]

THE ALMS DAS ALMOSEN L'AUMONE
(*Kassel, Galerie*)
F. Hanfstaengl, Photo.

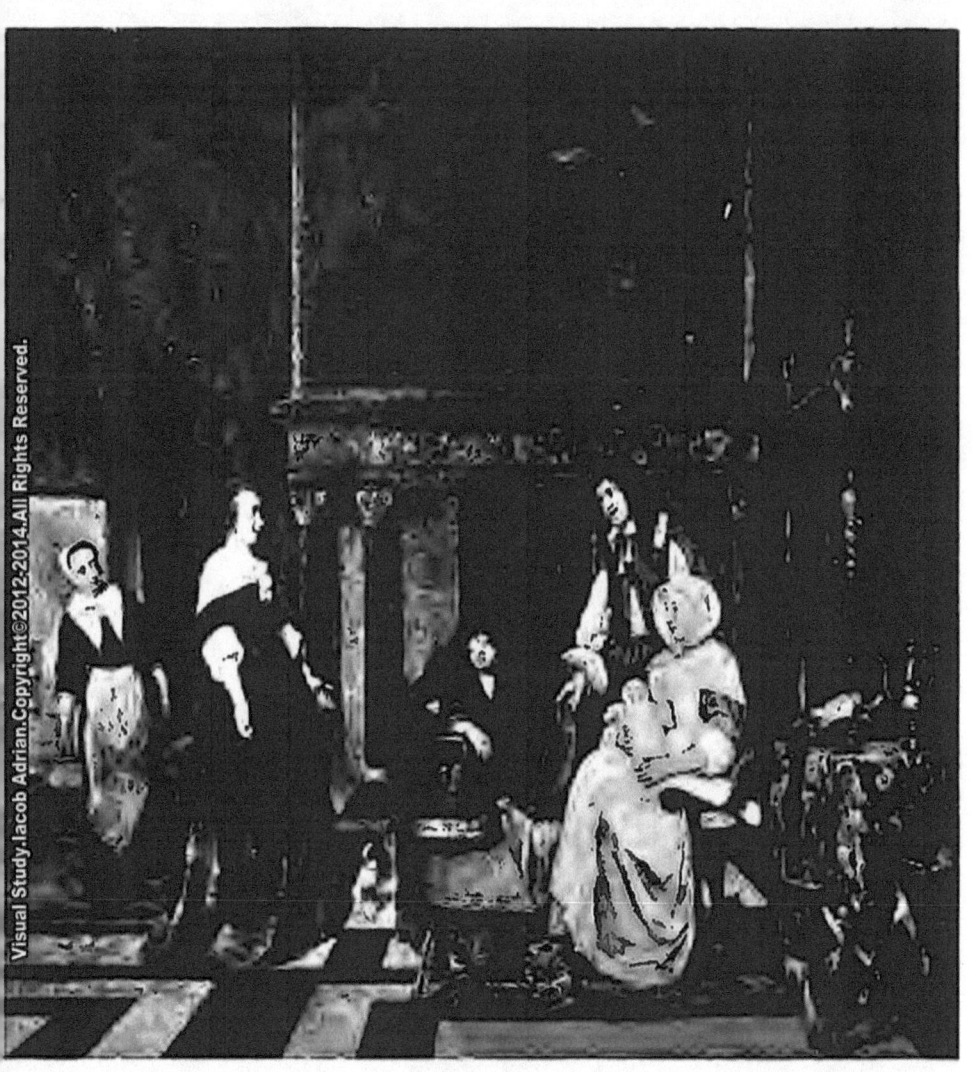

THE VISIT TO THE NURSERY [110] LA VISITE A LA CHAMBRE DES ENFANTS
DER BESUCH IN DER KINDERSTUBE
(*Mr. J. Pierpont Morgan, New York*)

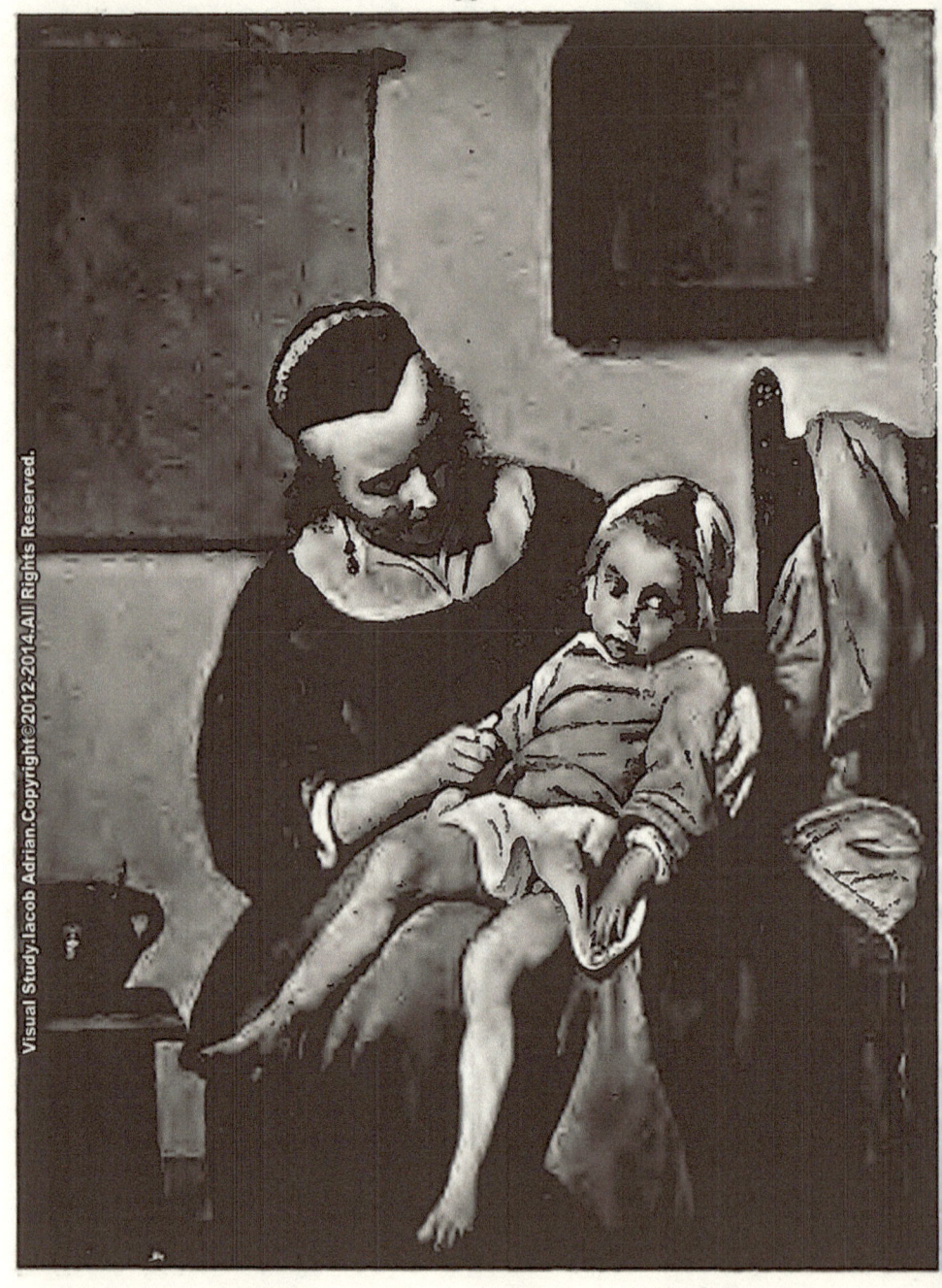

THE SICK CHILD [111] L'ENFANT MALADE
(*Steengracht Collection, The Hague*) (*Collection Steengracht, La Haye*)
DAS KRANKE KIND
(*Haag, Sammlung Steengracht*)
Medici-Bruckmann, Photo.

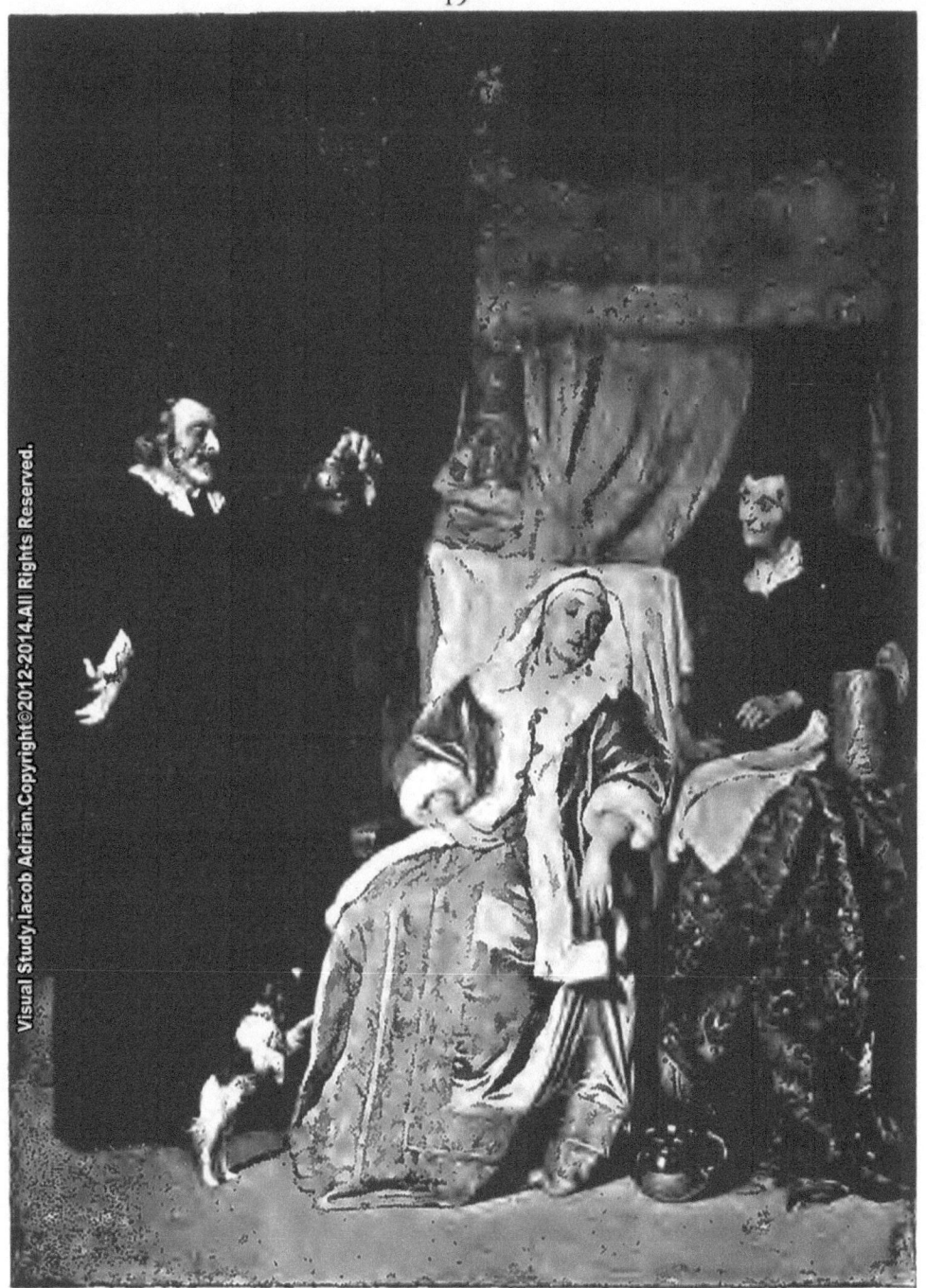

THE SICK LADY [114] LA DAME MALADE
DIE KRANKE DAME
(*Hermitage, St. Petersburg*)
F. Hanfstaengl, Photo.

THE SICK LADY [115] LA DAME MALADE
DIE KRANKE DAME
(*Kaiser Friedrich-Museum, Berlin*)
Photo. Ges., Photo.

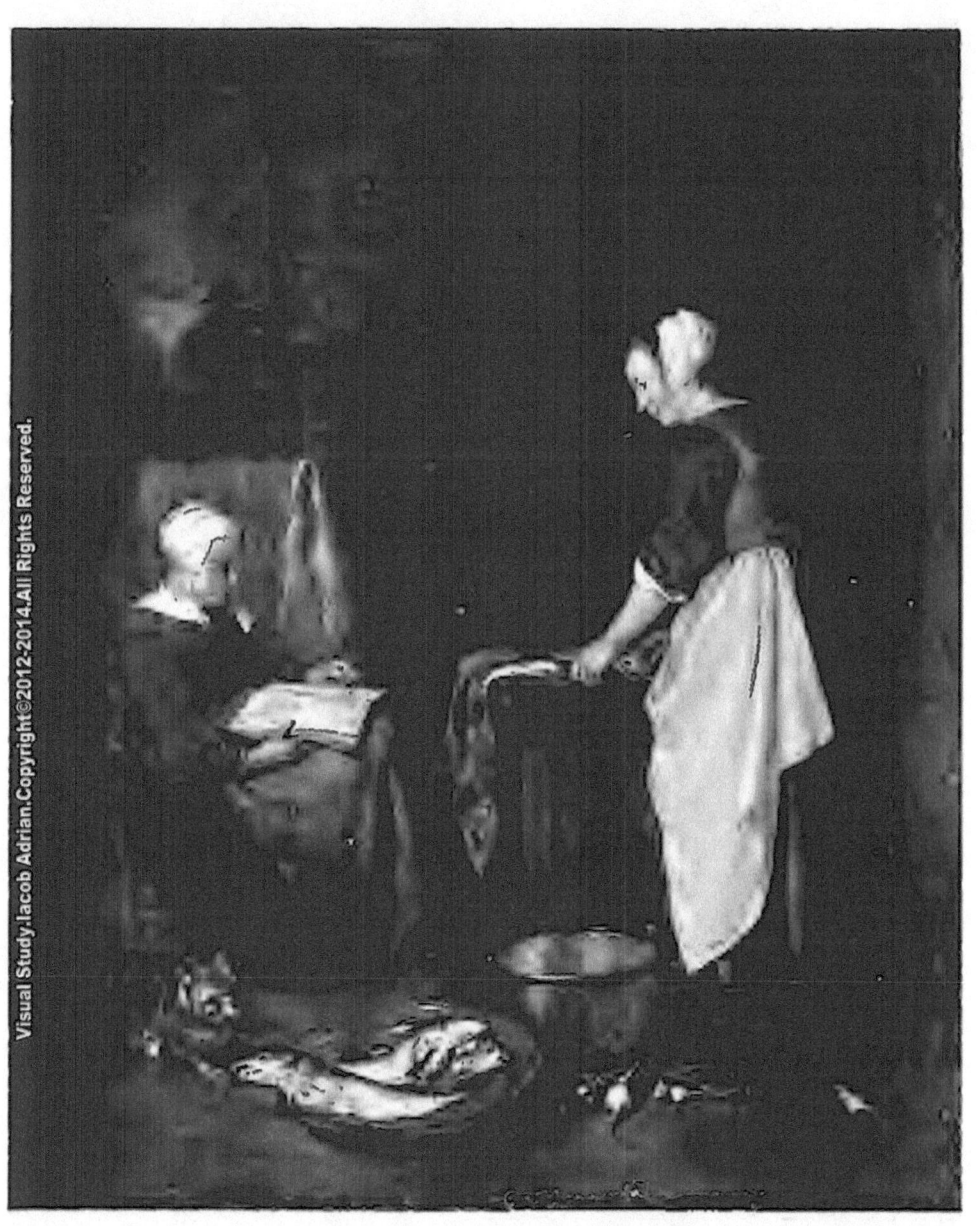

[122]
OLD WOMAN ASLEEP VIEILLE FEMME SOMMEILLANT
SCHLAFENDE ALTE FRAU
(*Wallace Collection, London*)
W. A. Mansell & Co., Photo.

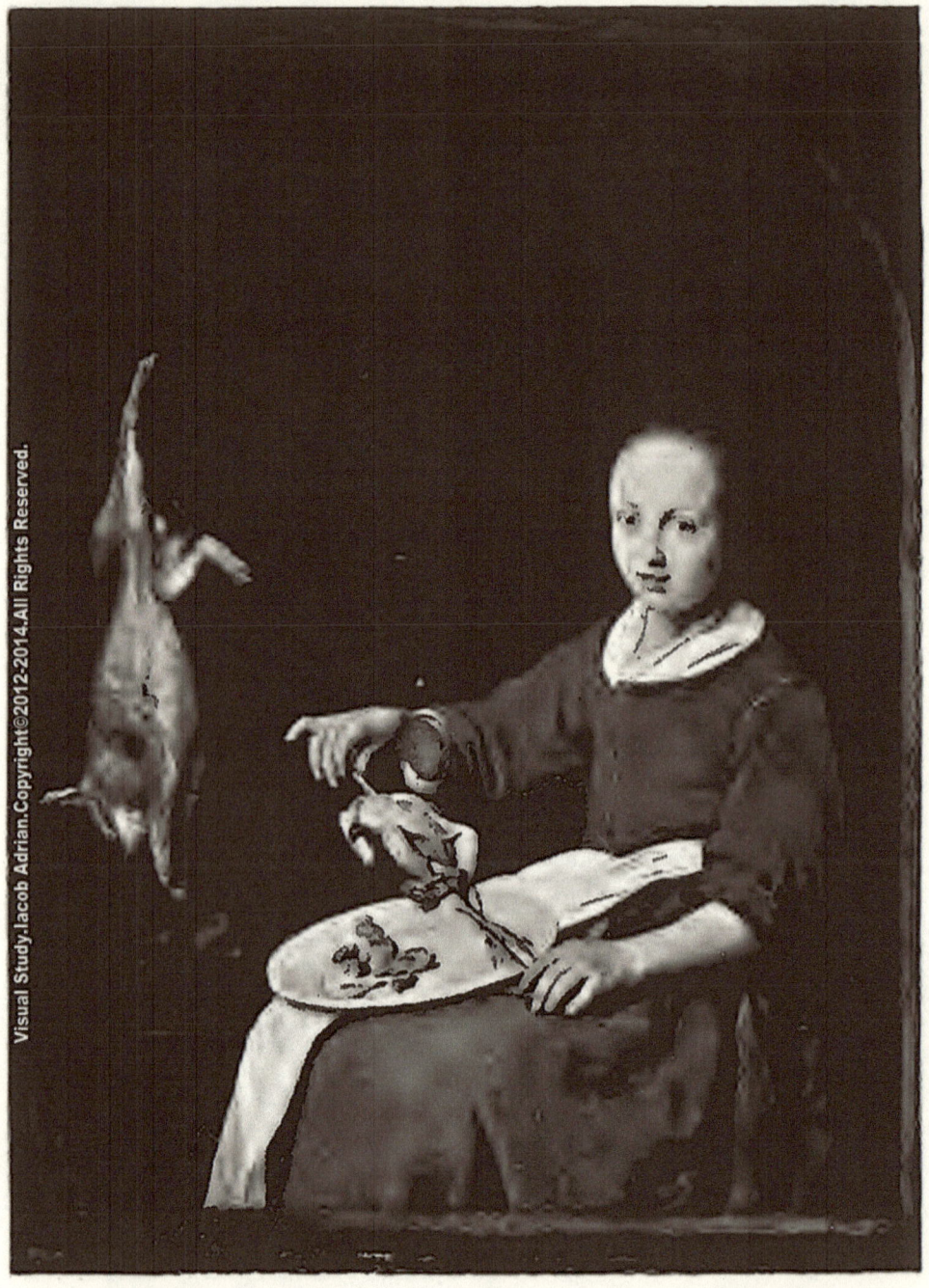

THE COOK [124] LA CUISINIÈRE
(*Pinacotheca, Munich*) (*Pinacothèque, Munich*)
DIE KÖCHIN
(*München, Pinakothek*)
F. Hanfstaengl, Photo.

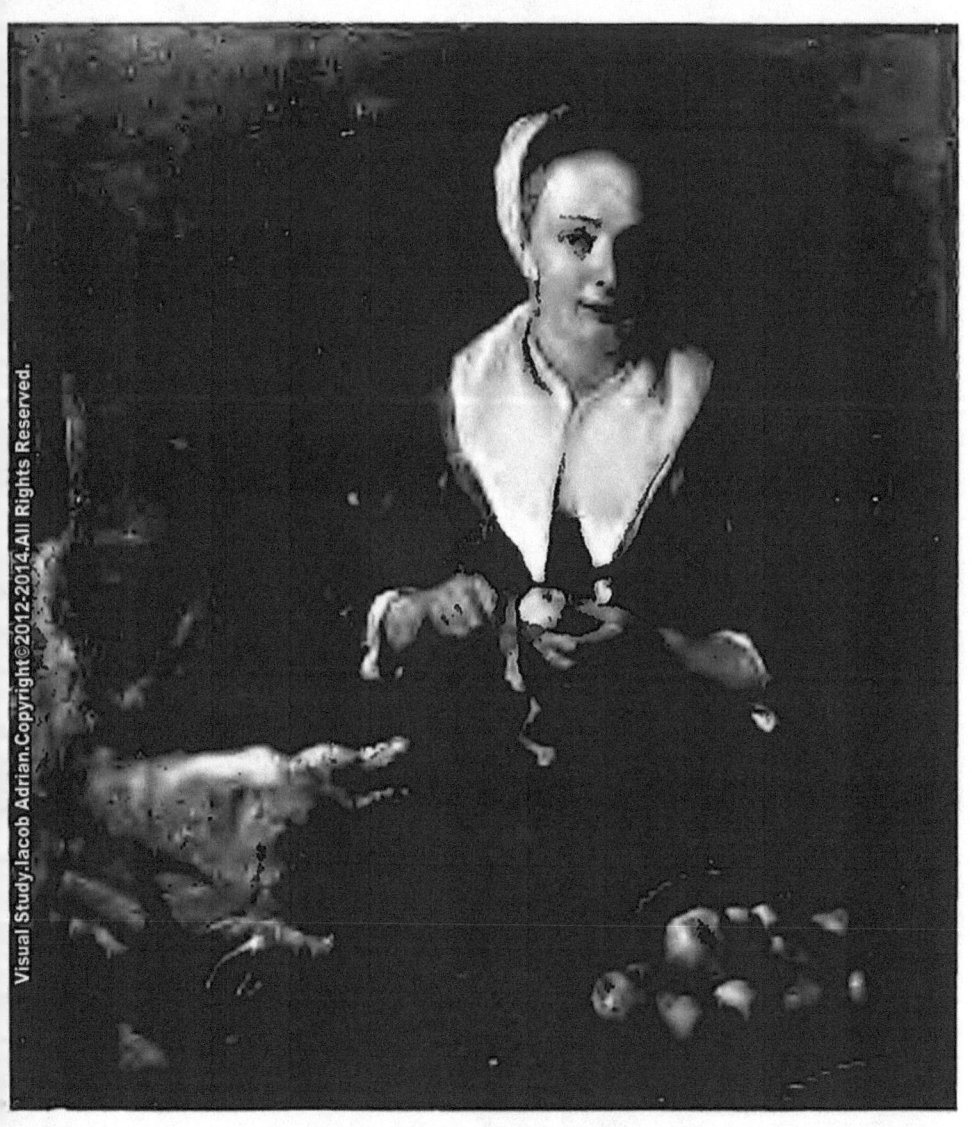

[125]
GIRL PARING APPLES JEUNE FILLE PELANT DES POMMES
ÄPFELSCHÄLENDES MÄDCHEN
(*Louvre, Paris*)
W. A. Mansell & Co., Photo.

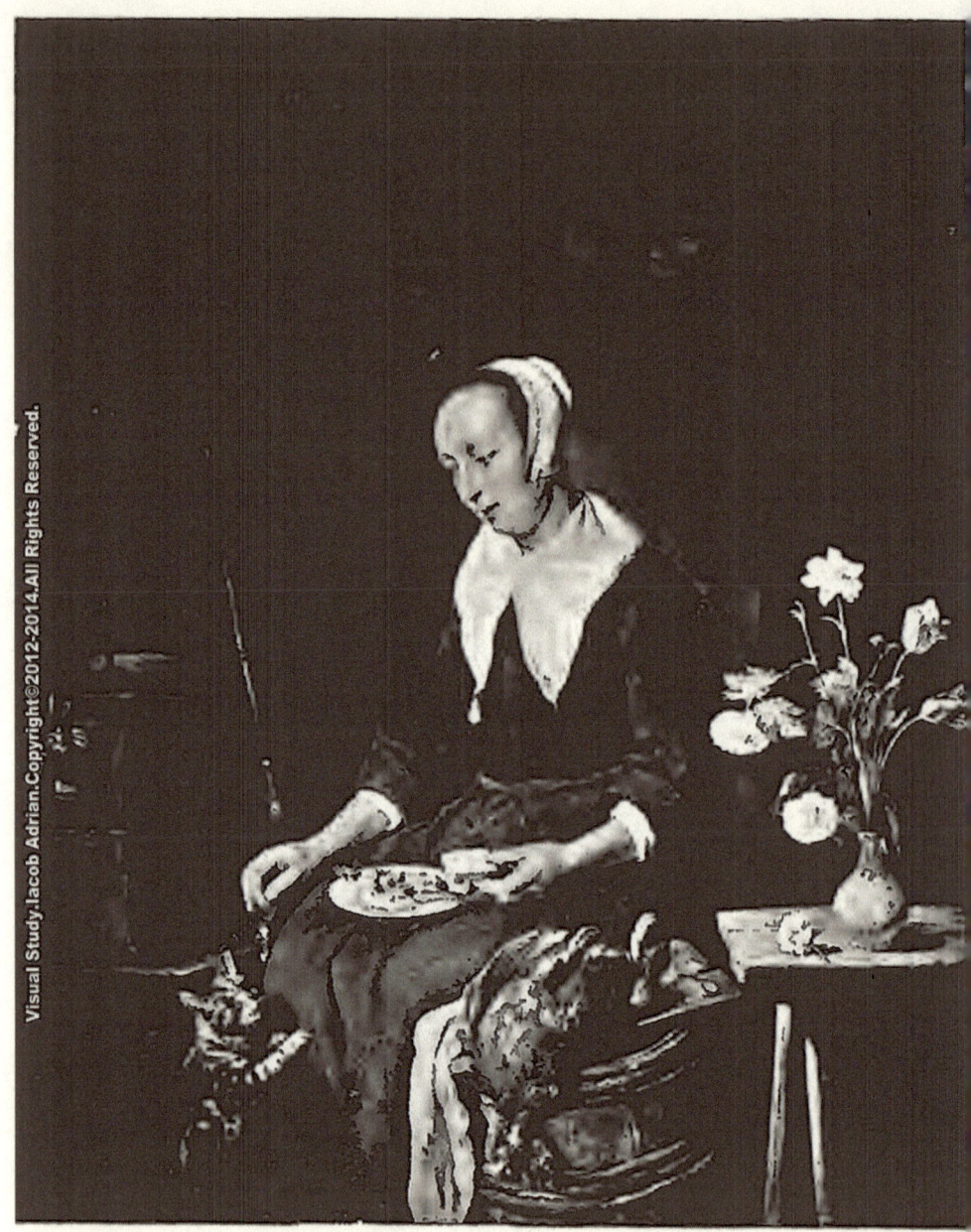

GIRL WITH CAT [133] JEUNE FILLE AVEC CHAT
MÄDCHEN MIT KATZE
(*Rijksmuseum, Amsterdam*)
Medici-Bruckmann, Photo.

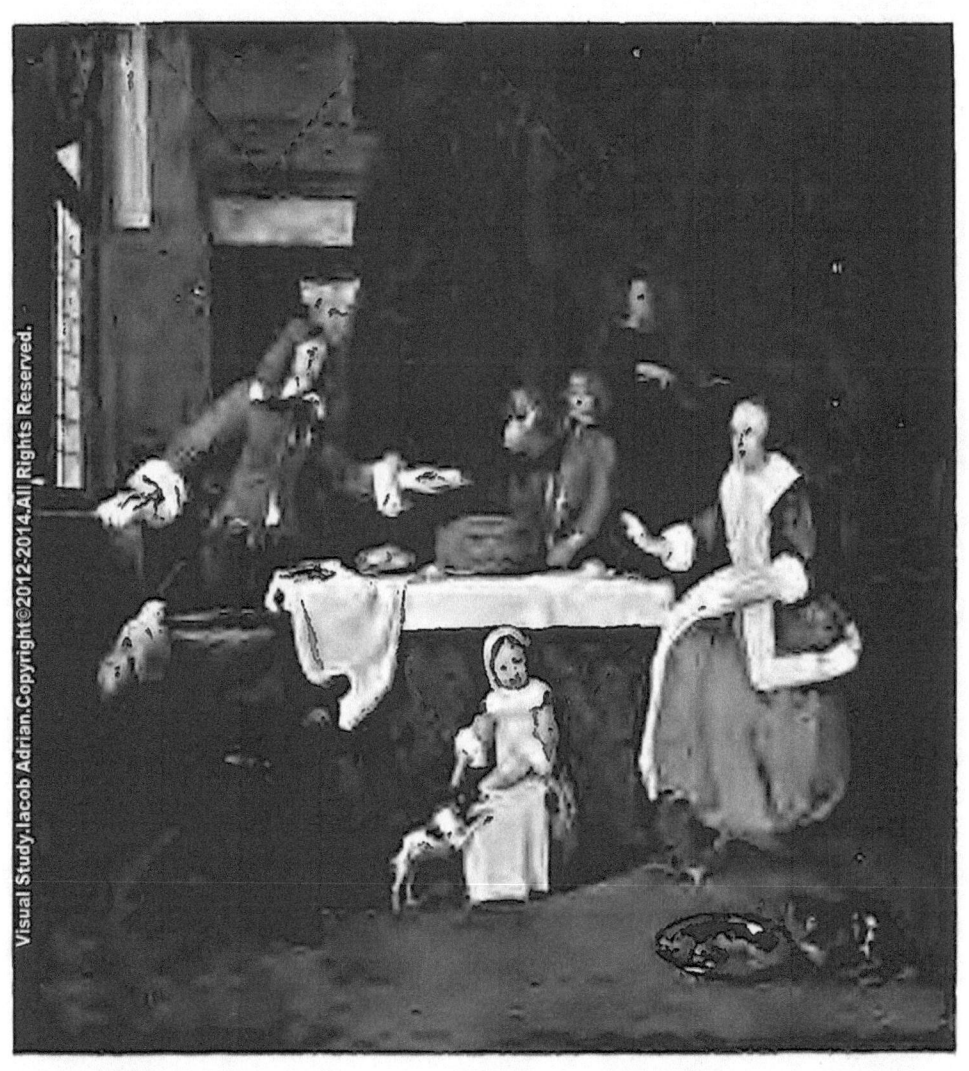

A FAMILY AT TABLE [135] UNE FAMILLE A TABLE
EINE FAMILIE BEI TISCHE
(*Hermitage, St. Petersburg*)
F. Hanfstaengl, Photo.

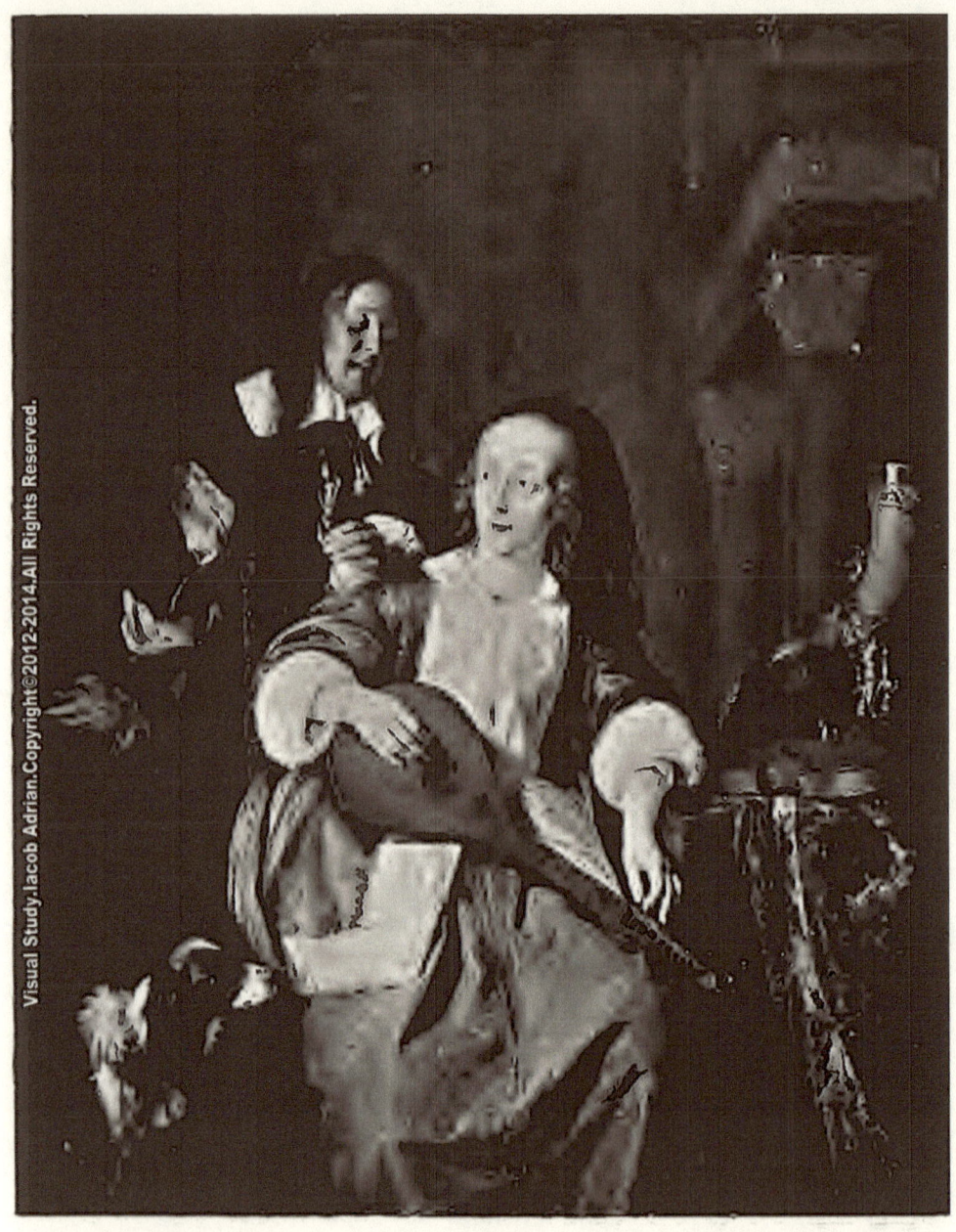

THE LUTE-PLAYER [146] LA JOUEUSE DE LUTH
DIE LAUTENSPIELERIN
(*Kassel, Galerie*)
F. Hanfstaengl, Photo.

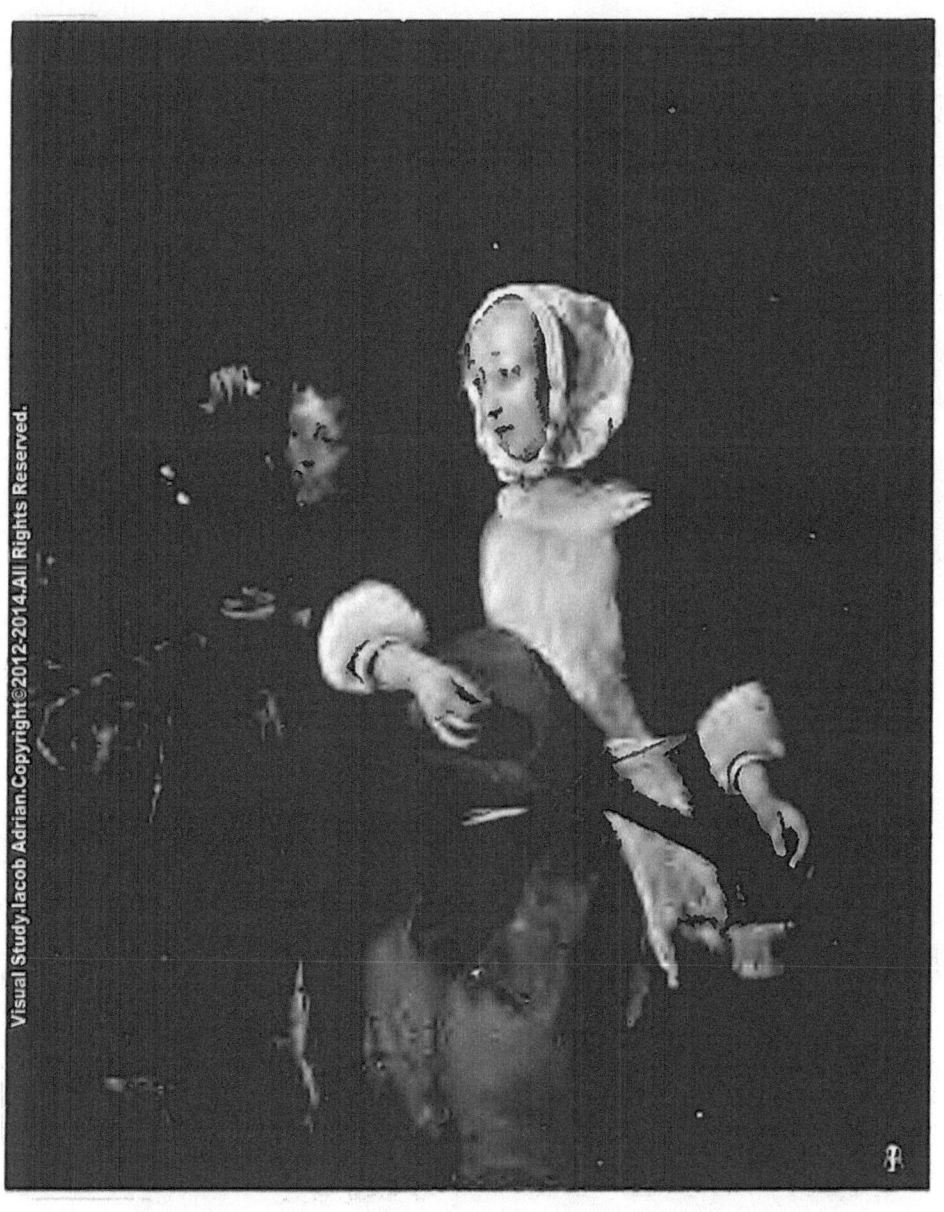

LADY TUNING MANDOLINE [147] DAME ACCORDANT UNE
(*Uffizi, Florence*) MANDOLINE
(*Galerie des Offices, Florence*)
DIE MANDOLINENSTIMMENDE DAME
(*Florenz, Uffizien*) G. Brogi, Photo.

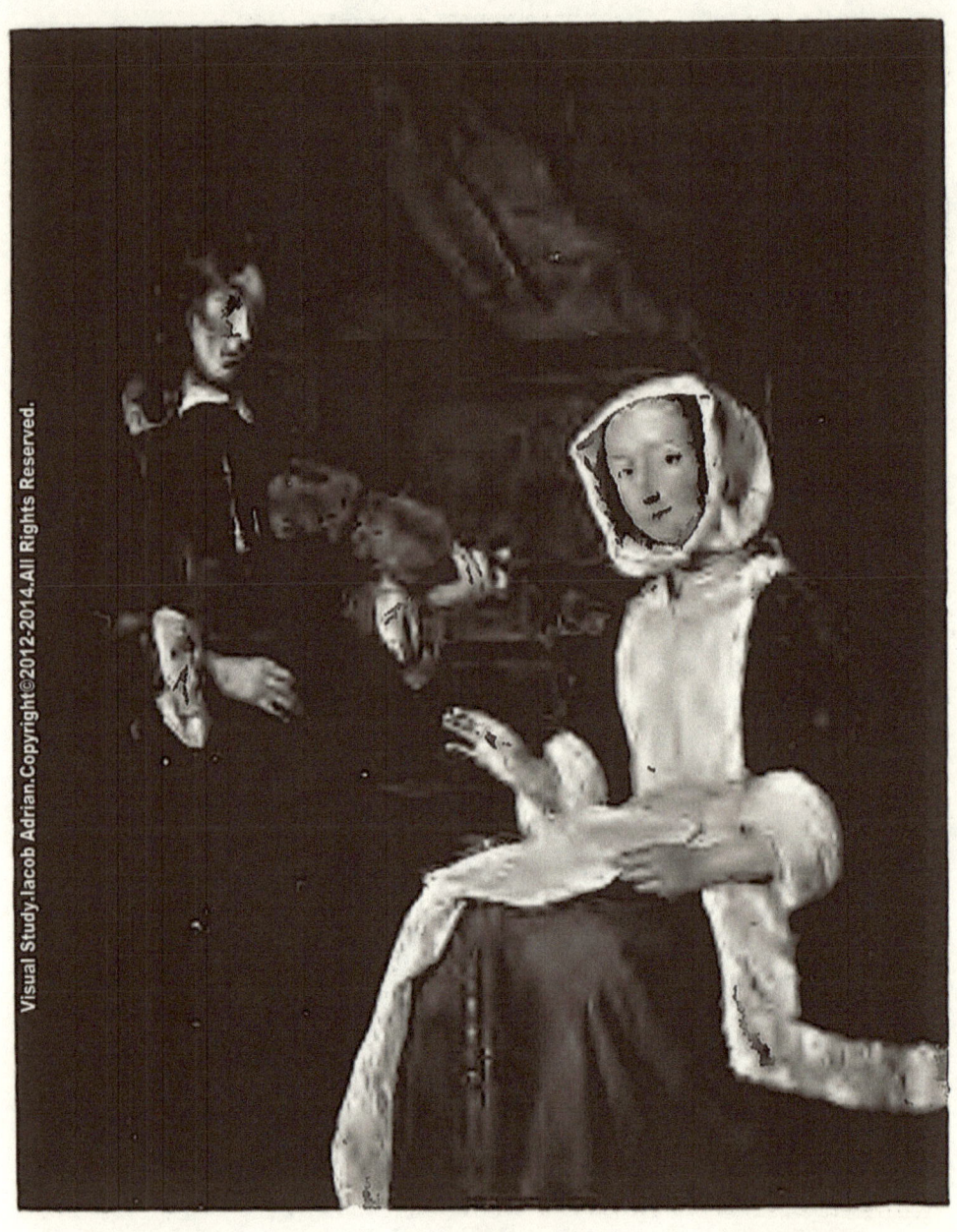

THE DUET [151] DAS DUETT LE DUO
(Hermitage, St. Petersburg)
F. Hanfstaengl, Photo.

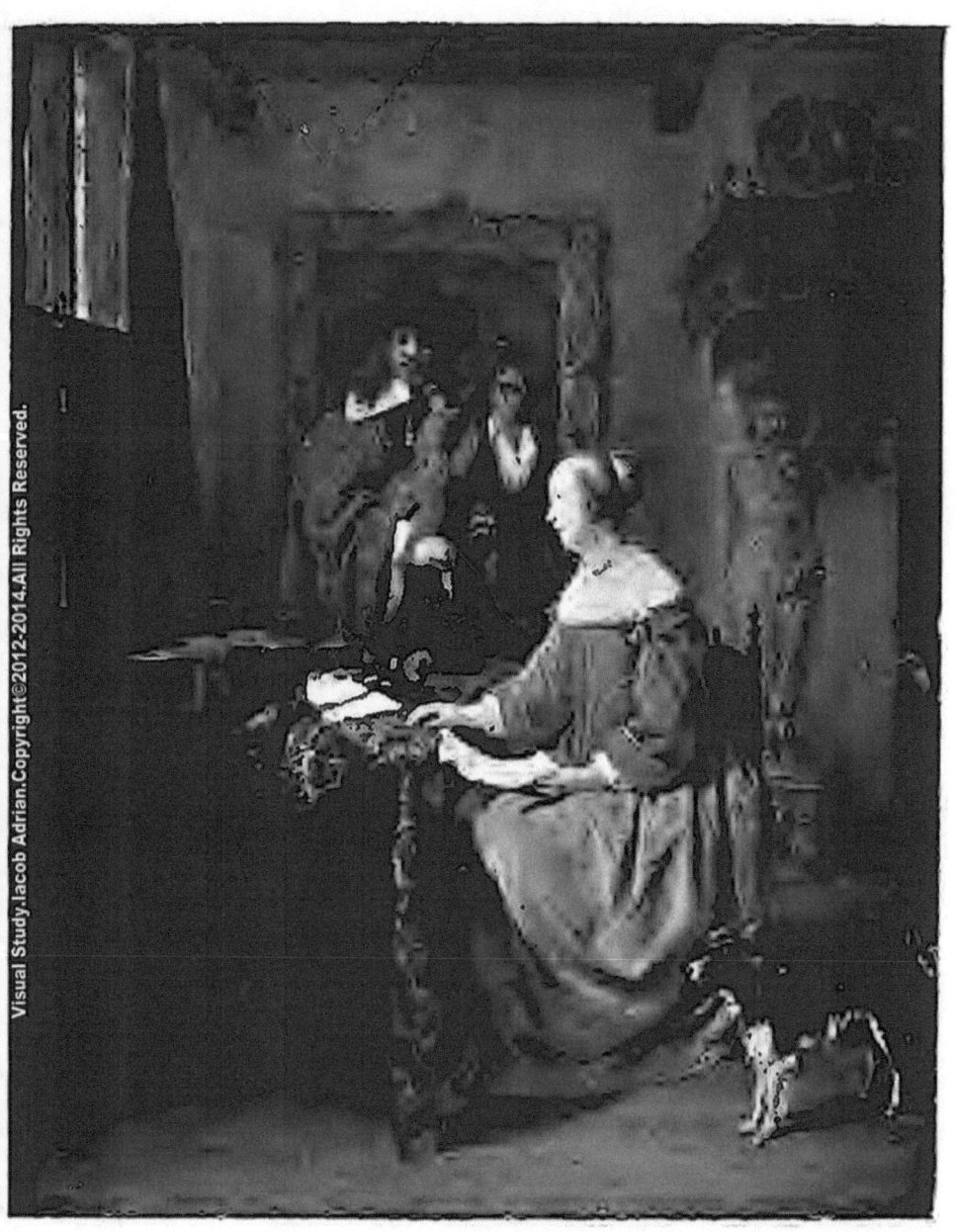

[154]

THE DUET · DAS DUETT · LE DUO
(National Gallery, London)
F. Hanfstaengl, Photo.

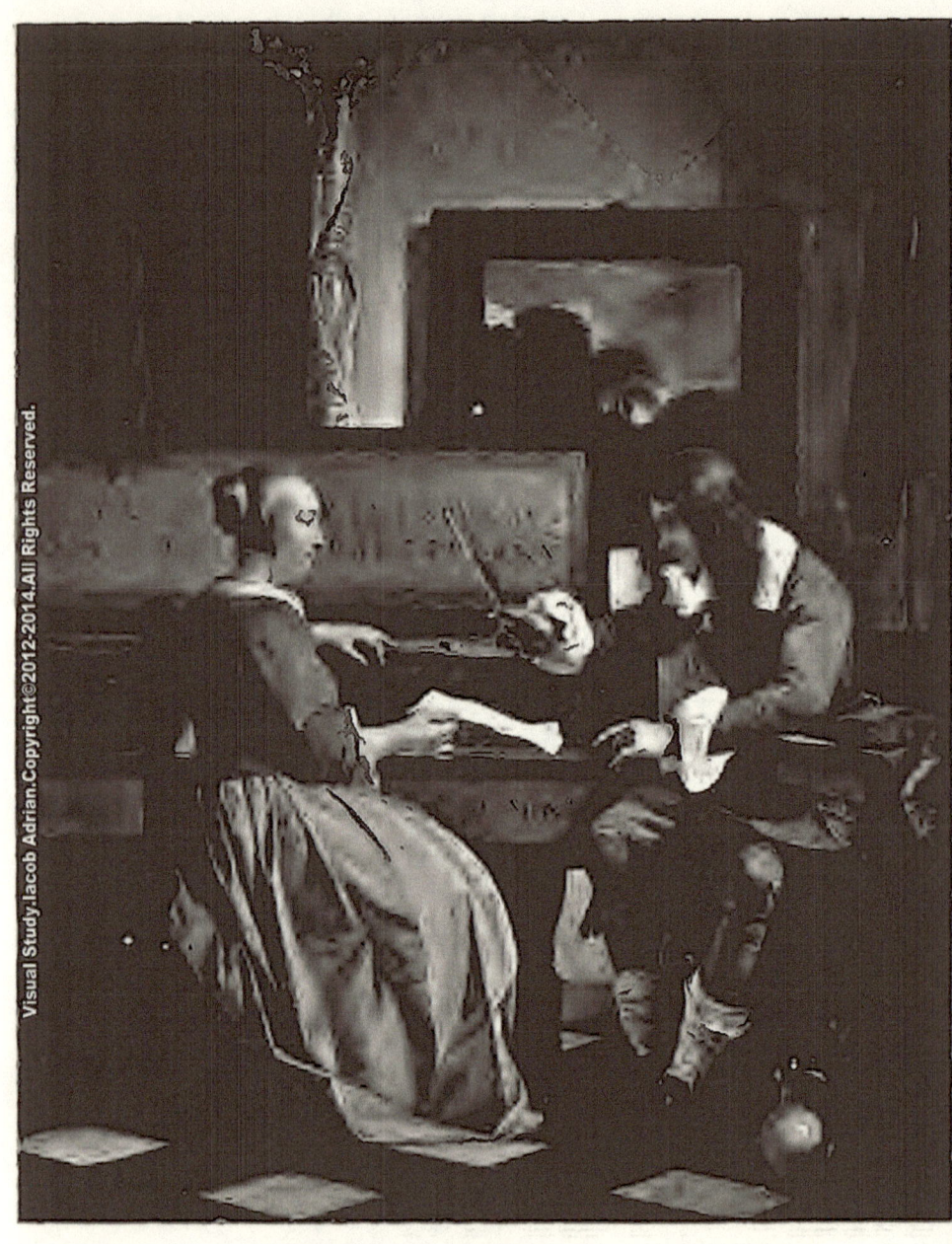

The Music-Lesson [155] La Leçon de Musique
Die Musikstunde
(National Gallery, London)
F. Hanfstaengl, Photo.

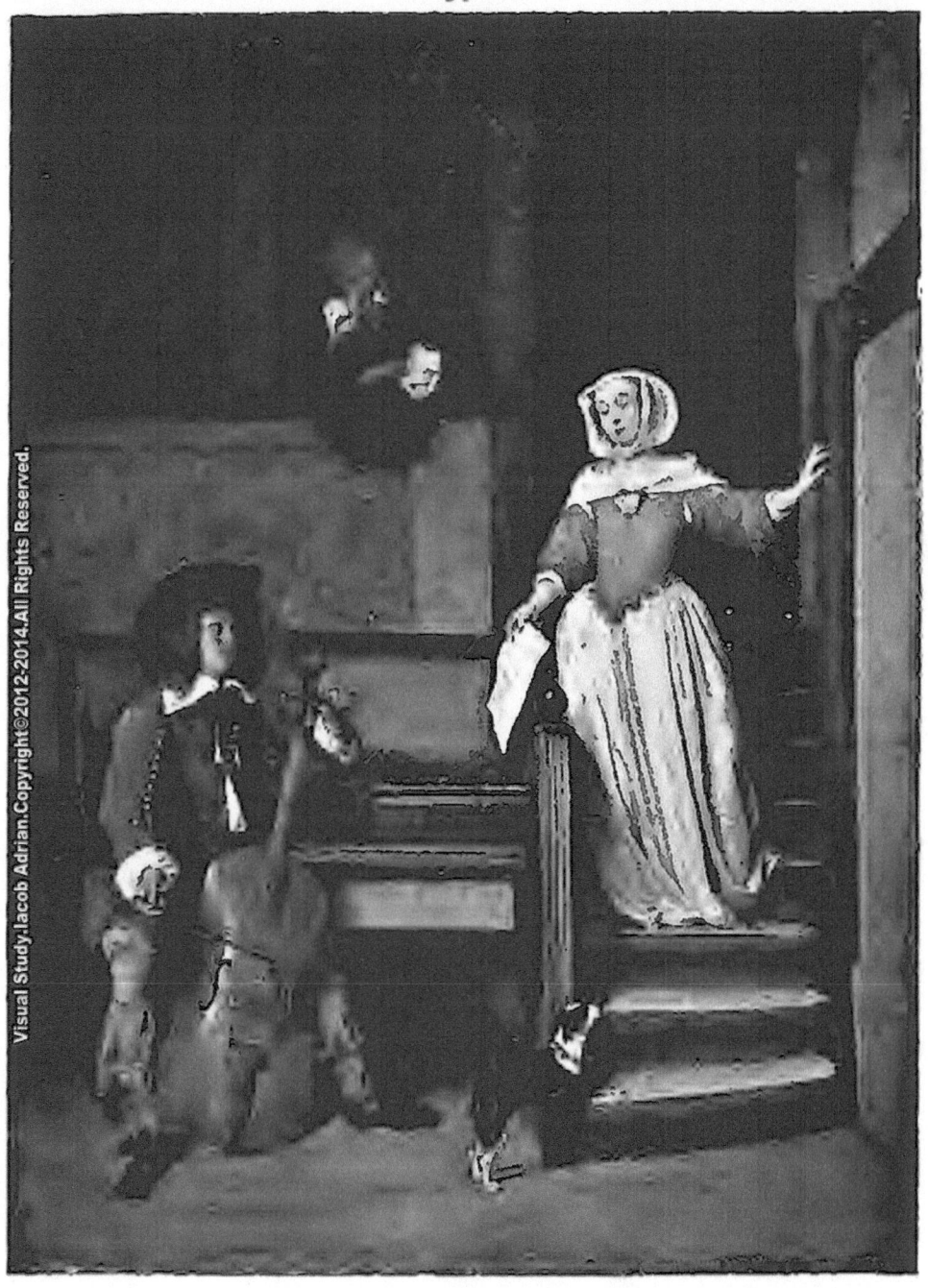

[156]
MAN PLAYING VIOLONCELLO HOMME JOUANT DU VIOLONCELLE
CELLO-SPIELENDER MANN
(*Buckingham Palace, London*)
F. Hanfstaengl, Photo.

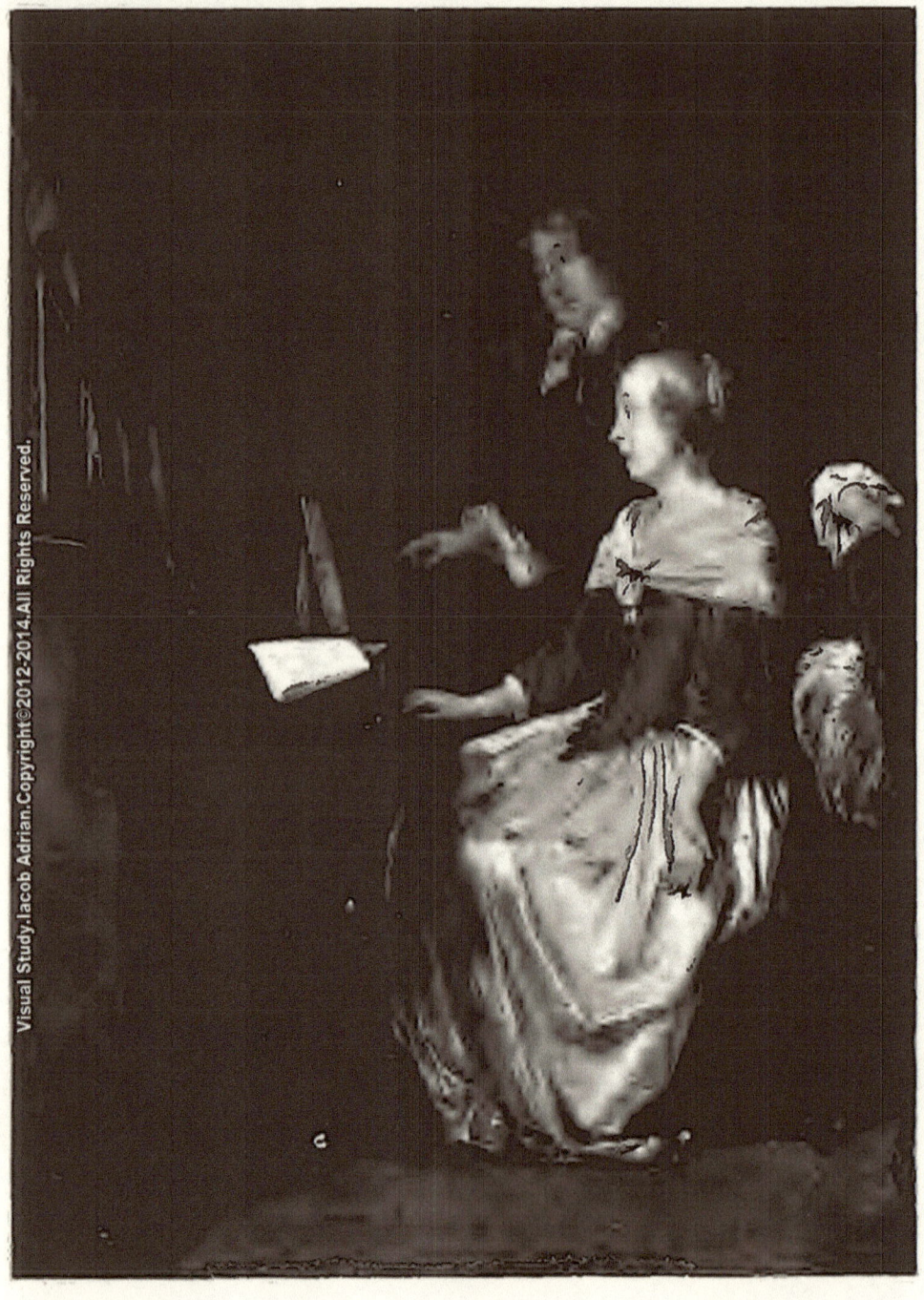

THE MUSIC-LESSON [158] LA LEÇON DE MUSIQUE
DIE MUSIKSTUNDE
(*Louvre, Paris*)
Frat. Alinari, Photo.

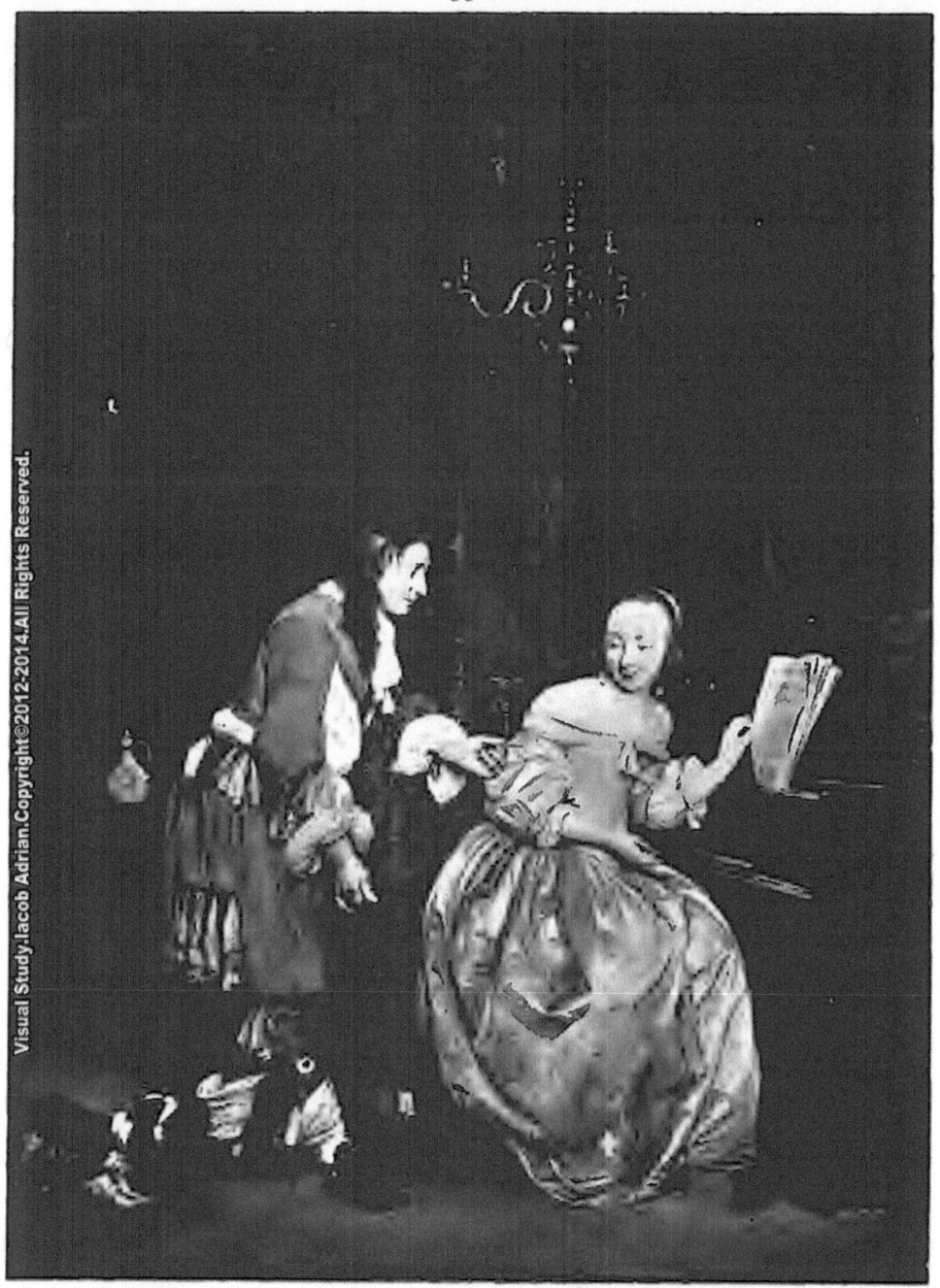

LADY AT THE HARPSICHORD [159] DAME AU CLAVECIN ET
AND GENTLEMAN GENTILHOMME
DAME AM SPINETT UND HERR
(*Sir Julius Wernher, London*)
Braun, Clément & Cie, Photo.

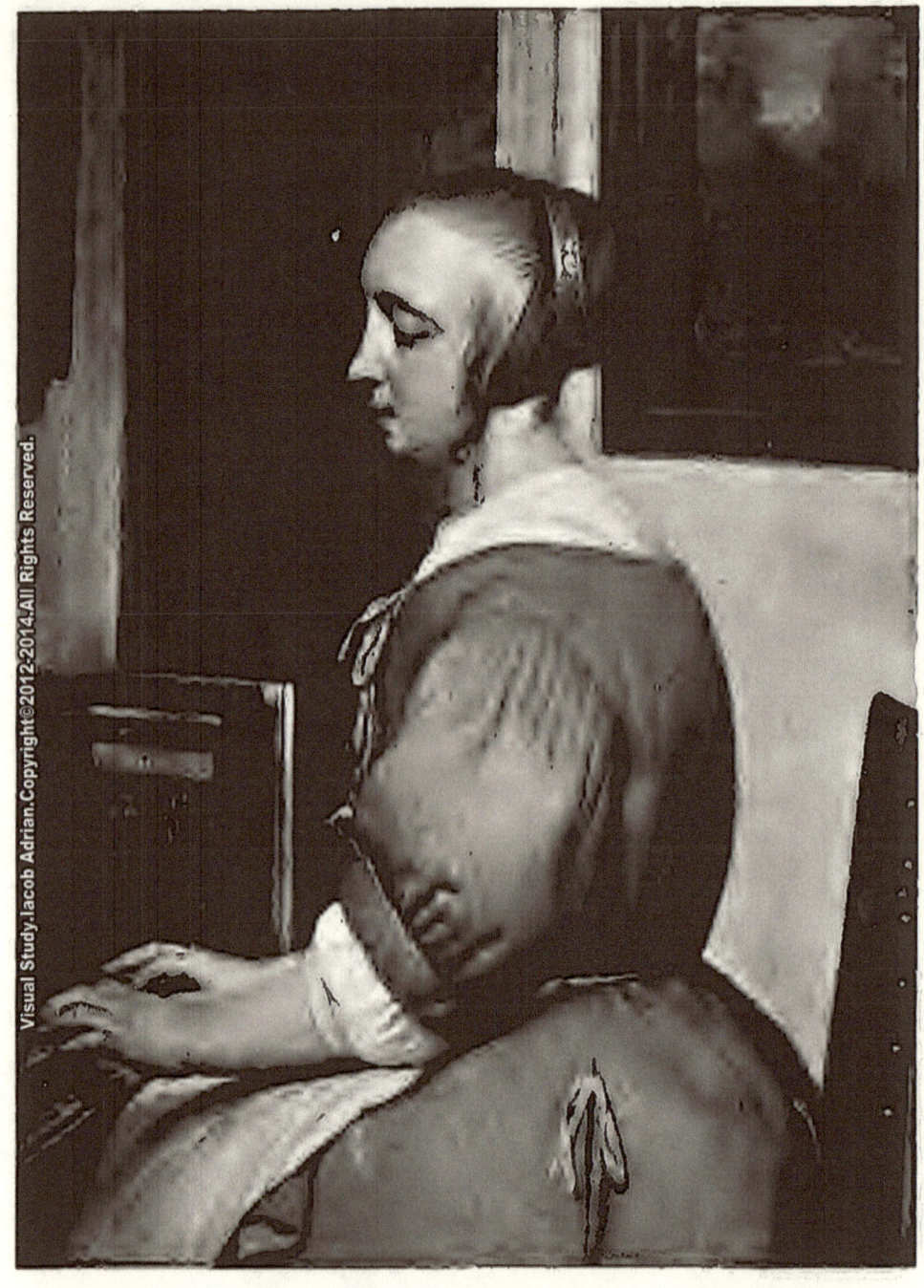

LADY AT HARPSICHORD [161] DAME AU CLAVECIN
DAME AM SPINETT
(*Petit Palais, Paris*)
J. E. Bulloz, Photo.

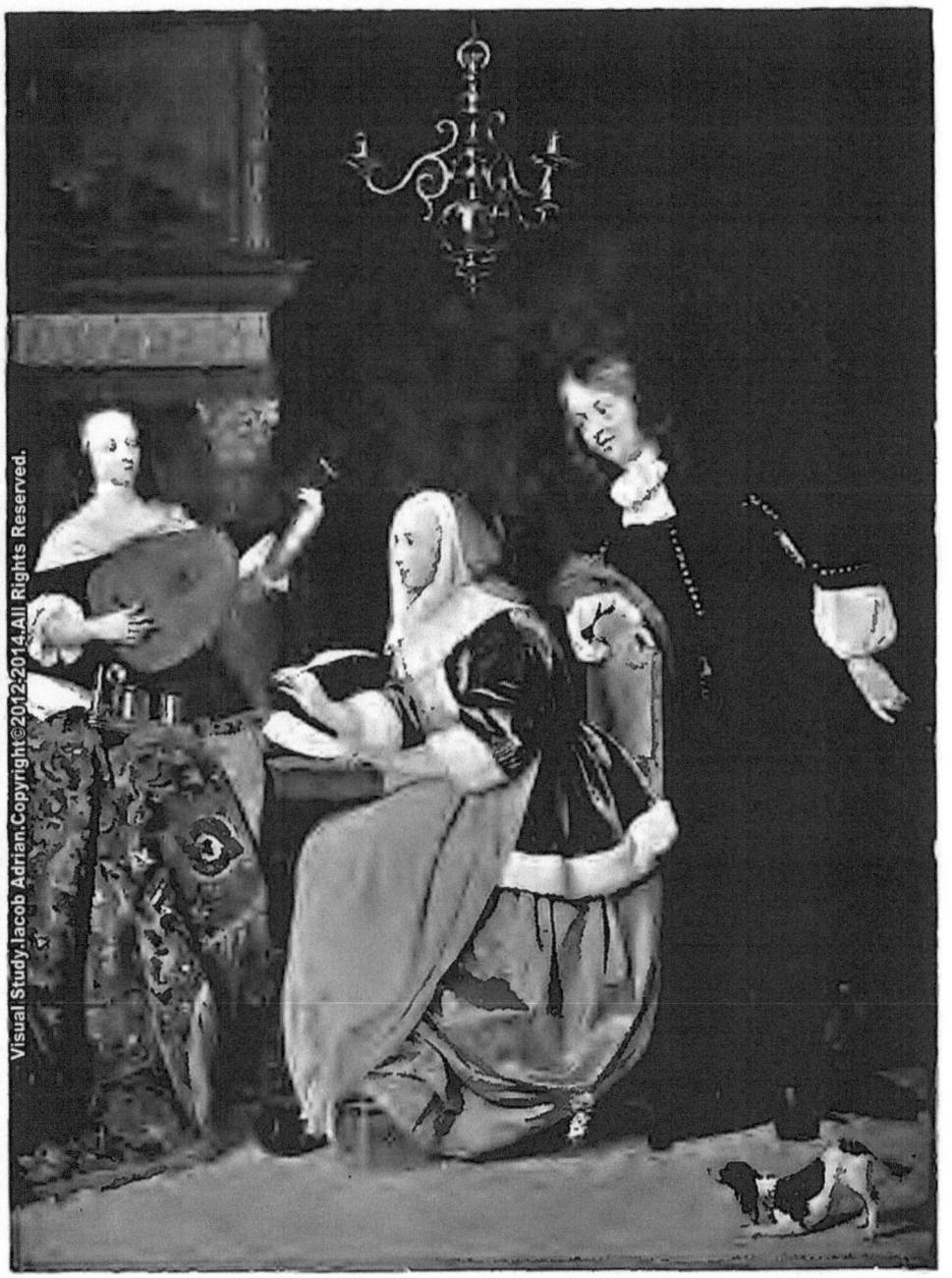

[162]

THE MUSIC-LOVERS (Royal Gallery, The Hague) LES AMATEURS DE MUSIQUE (Galerie royale, La Haye)

DIE MUSIKLIEBHABER (Haag, Kgl. Galerie)

F. Hanfstaengl, Photo.

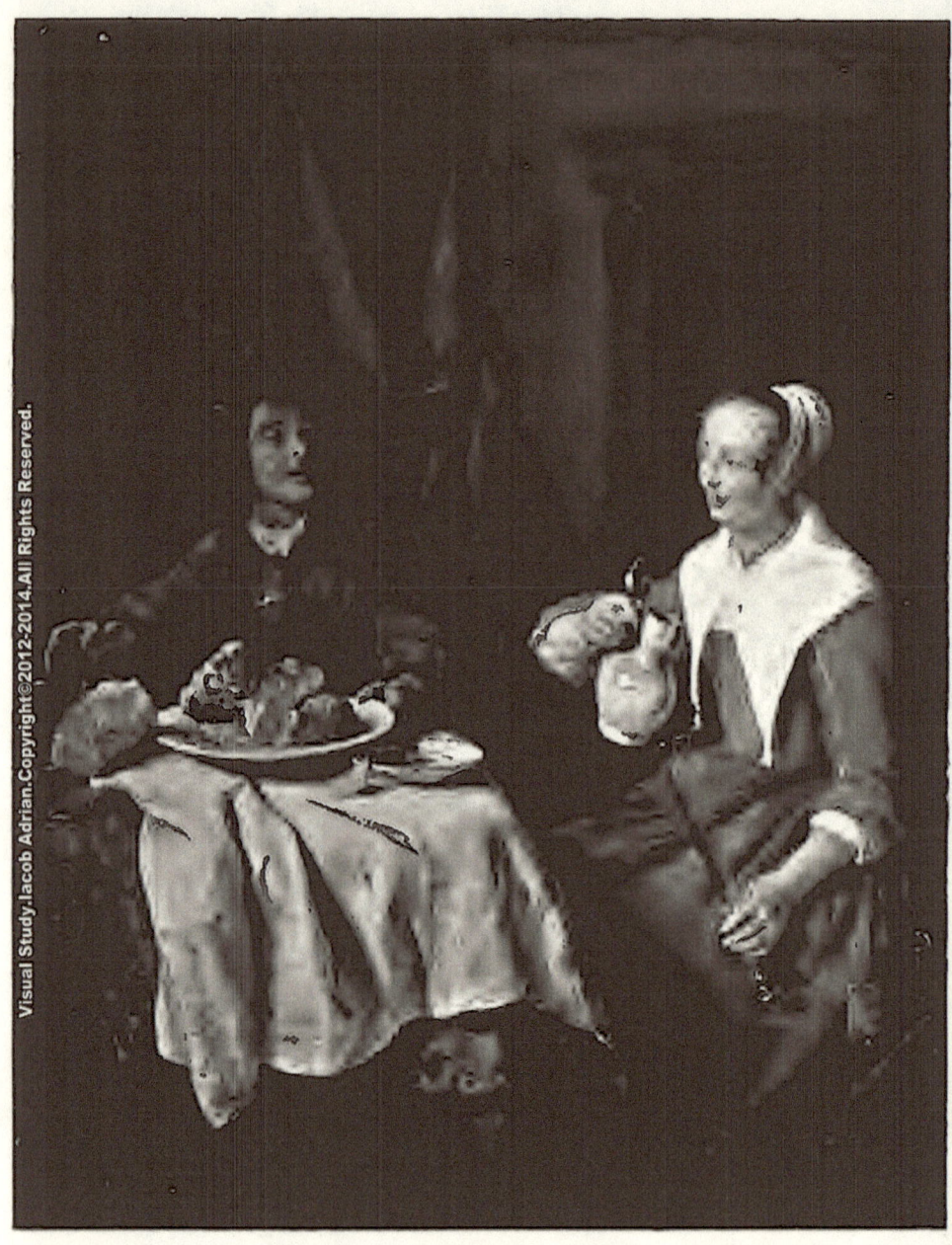

[167]

The Repast Das Mahl Le Repas
(*Rijksmuseum, Amsterdam*)
F. Hanfstaengl, Photo.

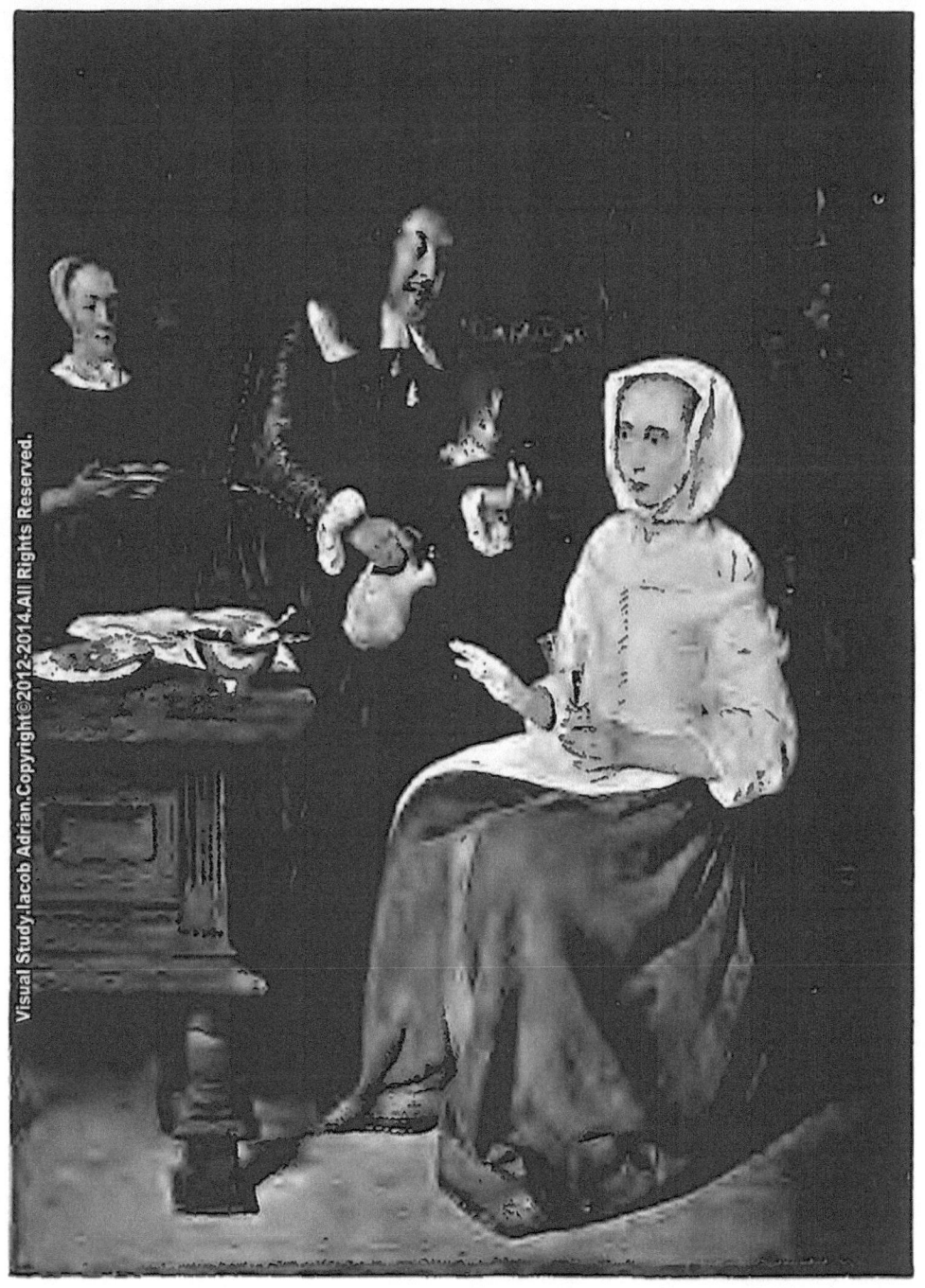

[168]

THE COLLATION DER IMBISS LA COLLATION
(*Museum, Brussels*) (*Brüssel, Museum*) (*Musée, Bruxelles*)
F. Hanfstaengl, Photo.

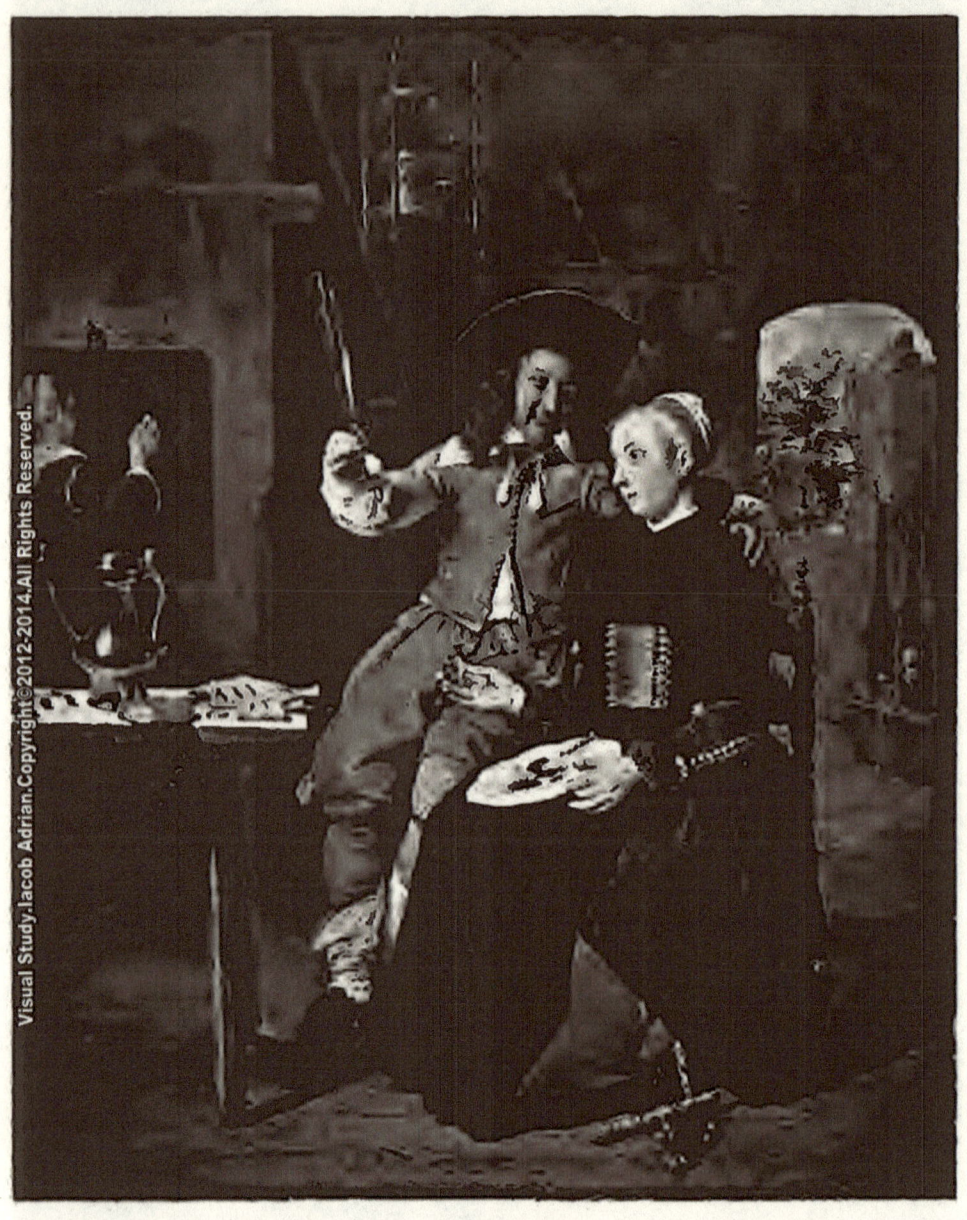

[169]
TWO LOVERS AT BREAKFAST DEUX AMANTS A DÉJEUNER
LIEBESPAAR BEIM FRÜHSTÜCK
(*Dresden, Galerie*)
F. Hanfstaengl, Photo.

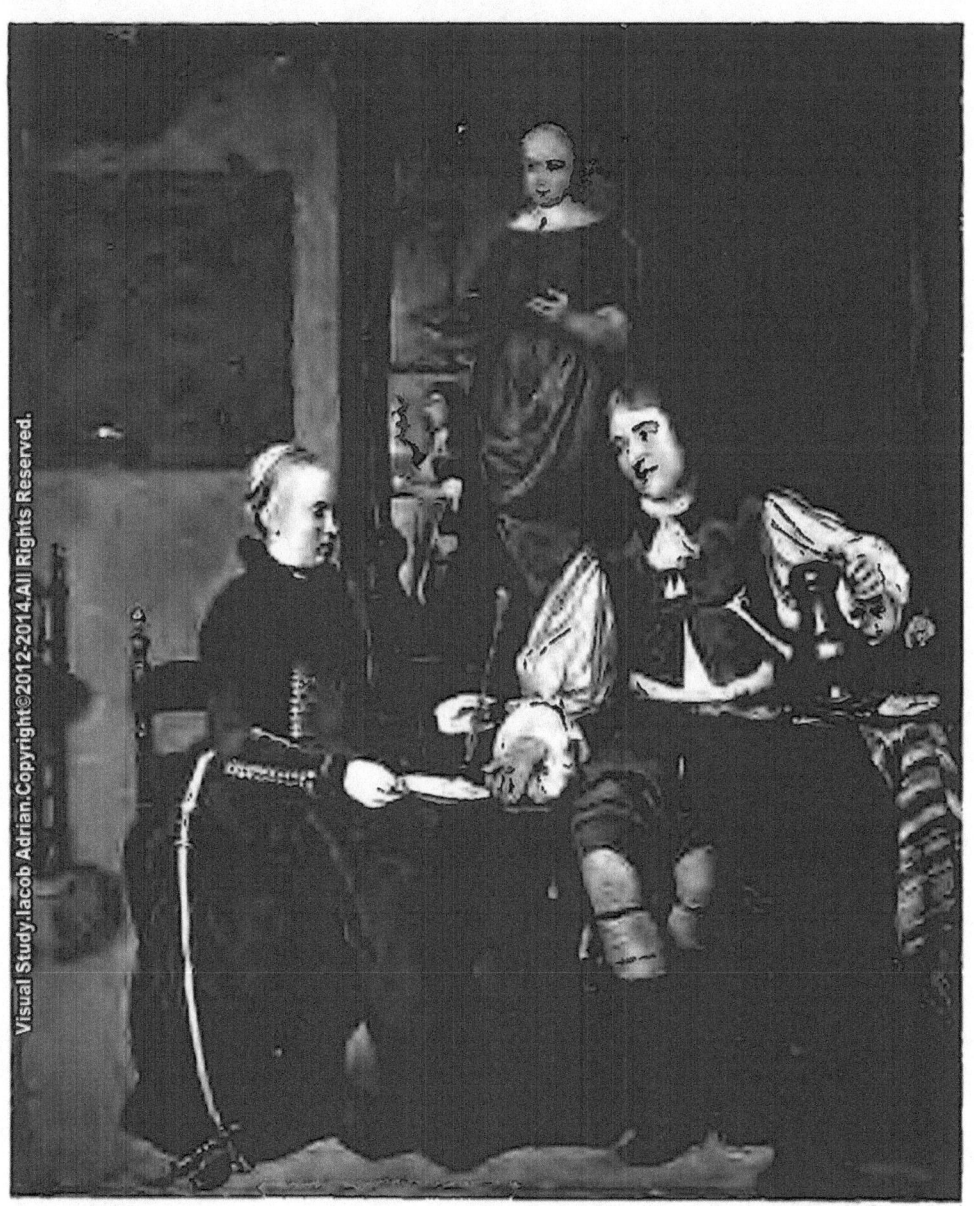

Young Couple at Breakfast [170] Jeune Couple a Déjeuner

Junges Paar beim Frühstück
(*Karlsruhe, Galerie*)
Medici-Bruckmann, Photo.

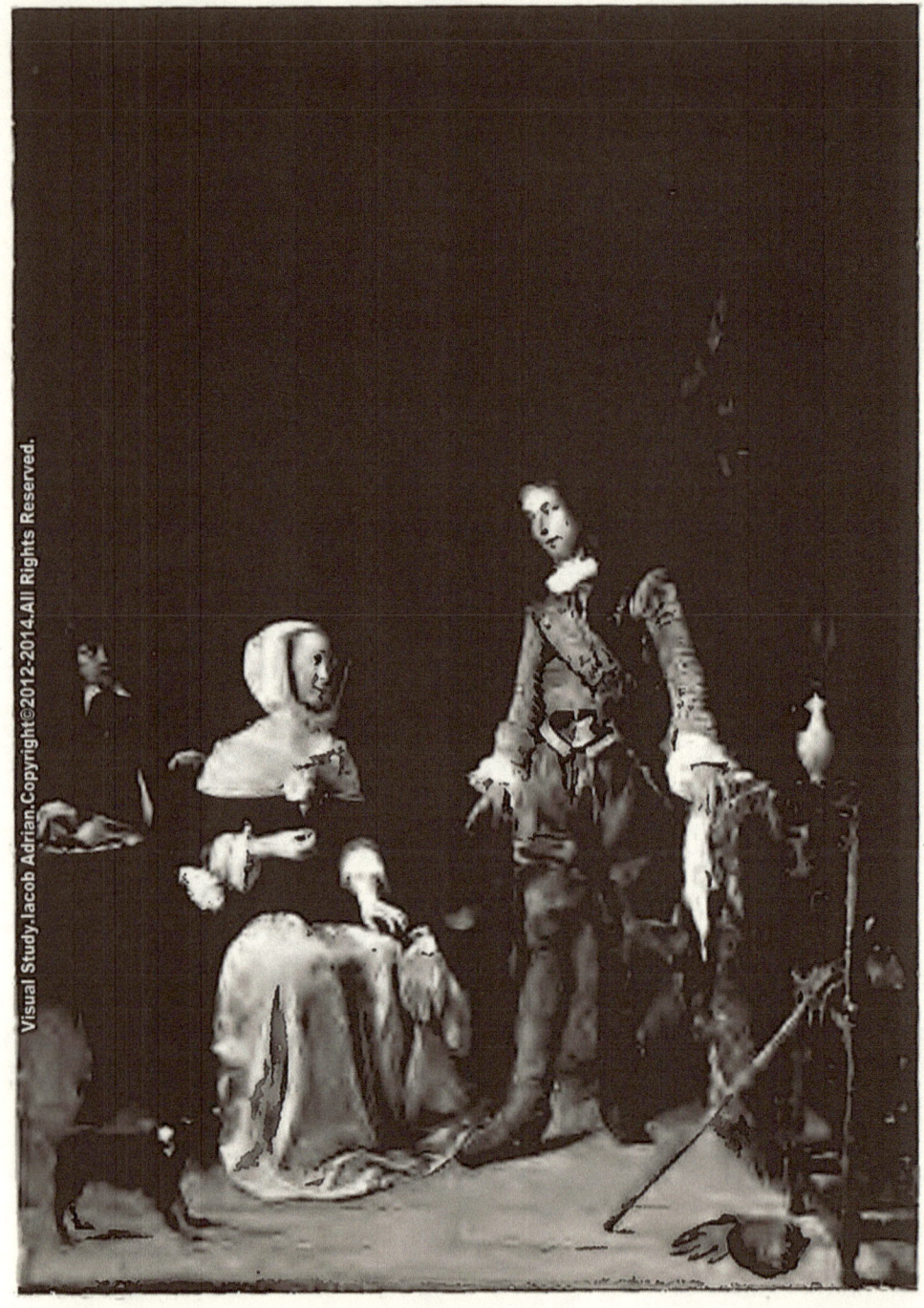

The Morning Visit [172] La Visite matinale
Der Morgenbesuch
(*Louvre, Paris*)
W. A. Mansell & Co., Photo.

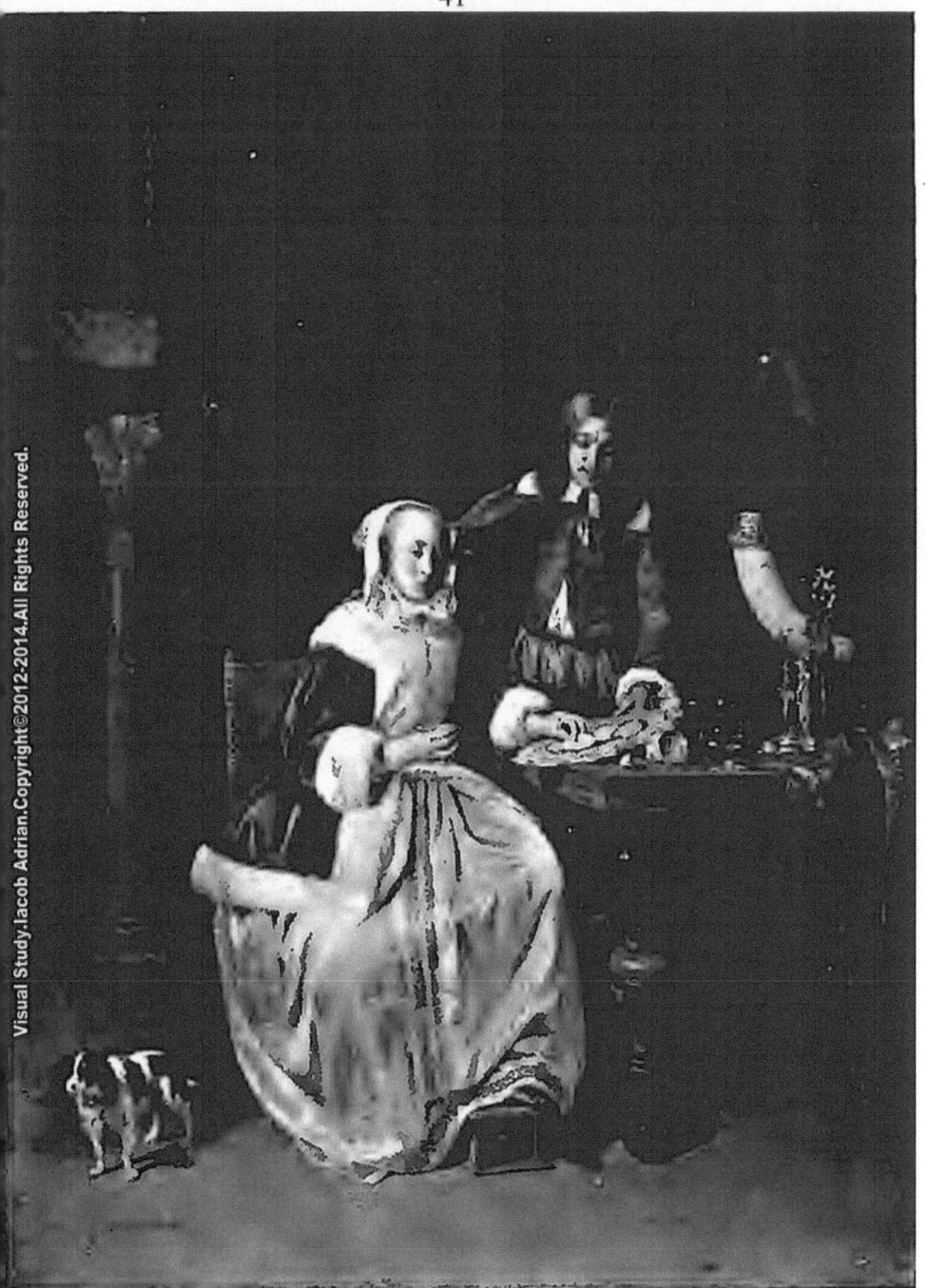

THE MEAL OF OYSTERS [174] LE REPAS D'HUÎTRES
DAS AUSTERNMAHL
(*Hermitage, St. Petersburg*)
F. Hanfstaengl, Photo.

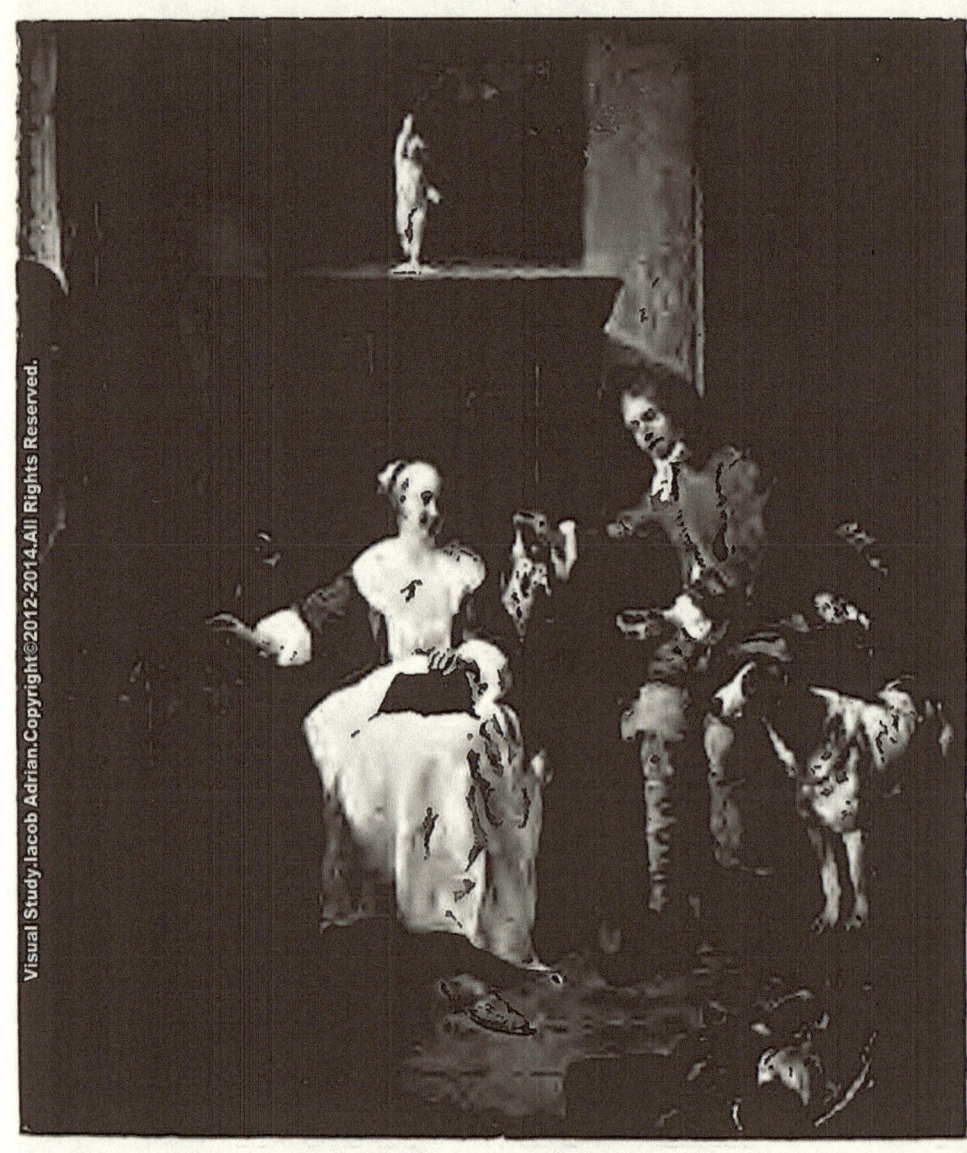

THE SPORTSMAN'S PRESENT [180] LE PRÉSENT DU CHASSEUR
DES JÄGERS GESCHENK
(*Rijksmuseum, Amsterdam*)
F. Hanfstaengl, Photo.

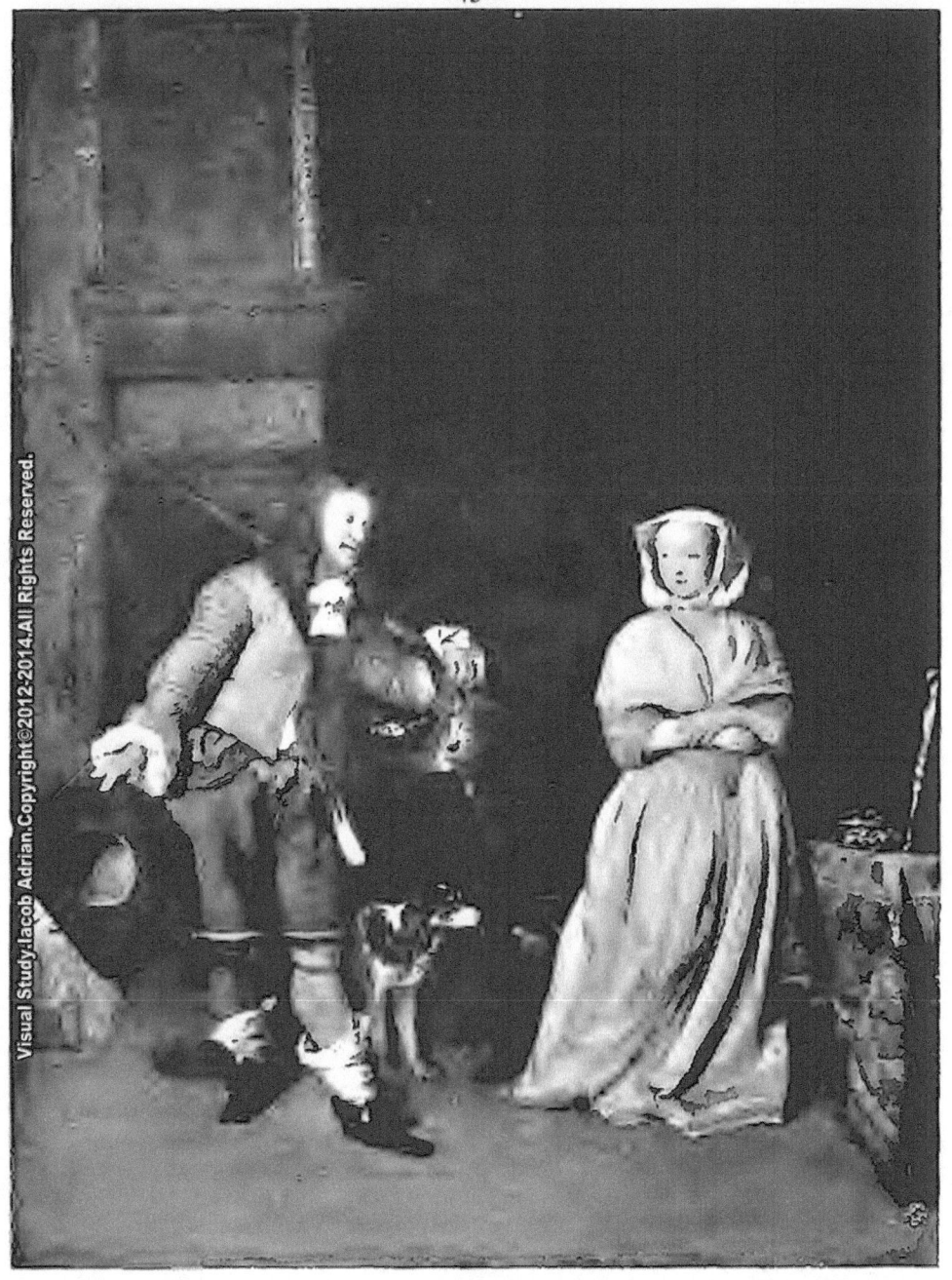

[181]

SPORTSMAN SALUTING LADY CHASSEUR SALUANT UNE DAME
(Uffizi, Florence) (Galerie des Offices, Florence)
JÄGER EINE DAME GRÜSSEND
(Florenz, Uffizien)
G. Brogi, Photo.

44

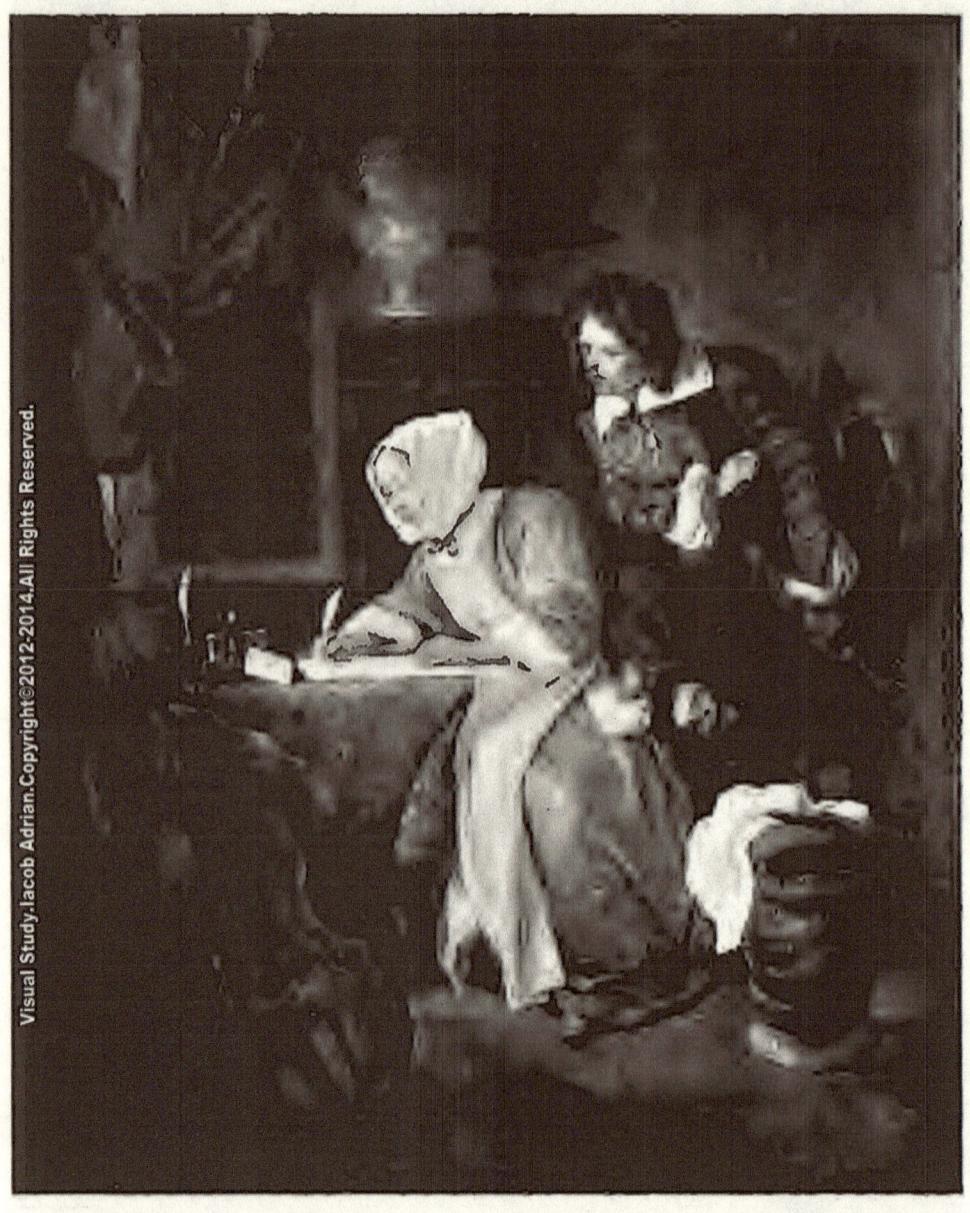

THE LETTER WRITER [186] LA DAME QUI ÉCRIT UNE
SURPRISED LETTRE EST SURPRISE
DIE ÜBERRASCHTE BRIEFSCHREIBERIN
(*Wallace Collection, London*)
W. A. Mansell & Co., Photo.

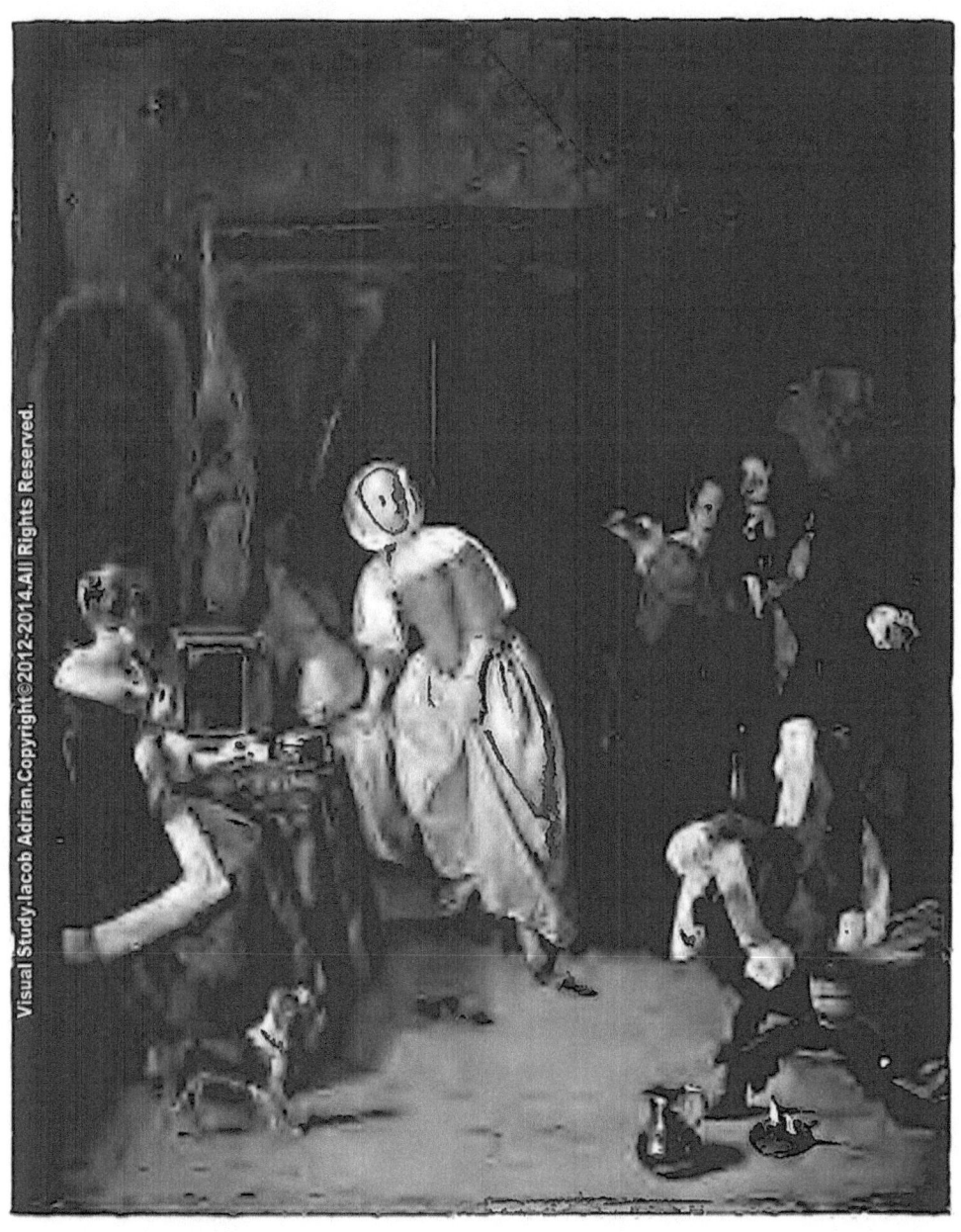

[190]
THE INTRUDER DER EINDRINGLING L'INTRUS
(*Earl of Northbrook, London*)
F. Hanfstaengl, Photo.

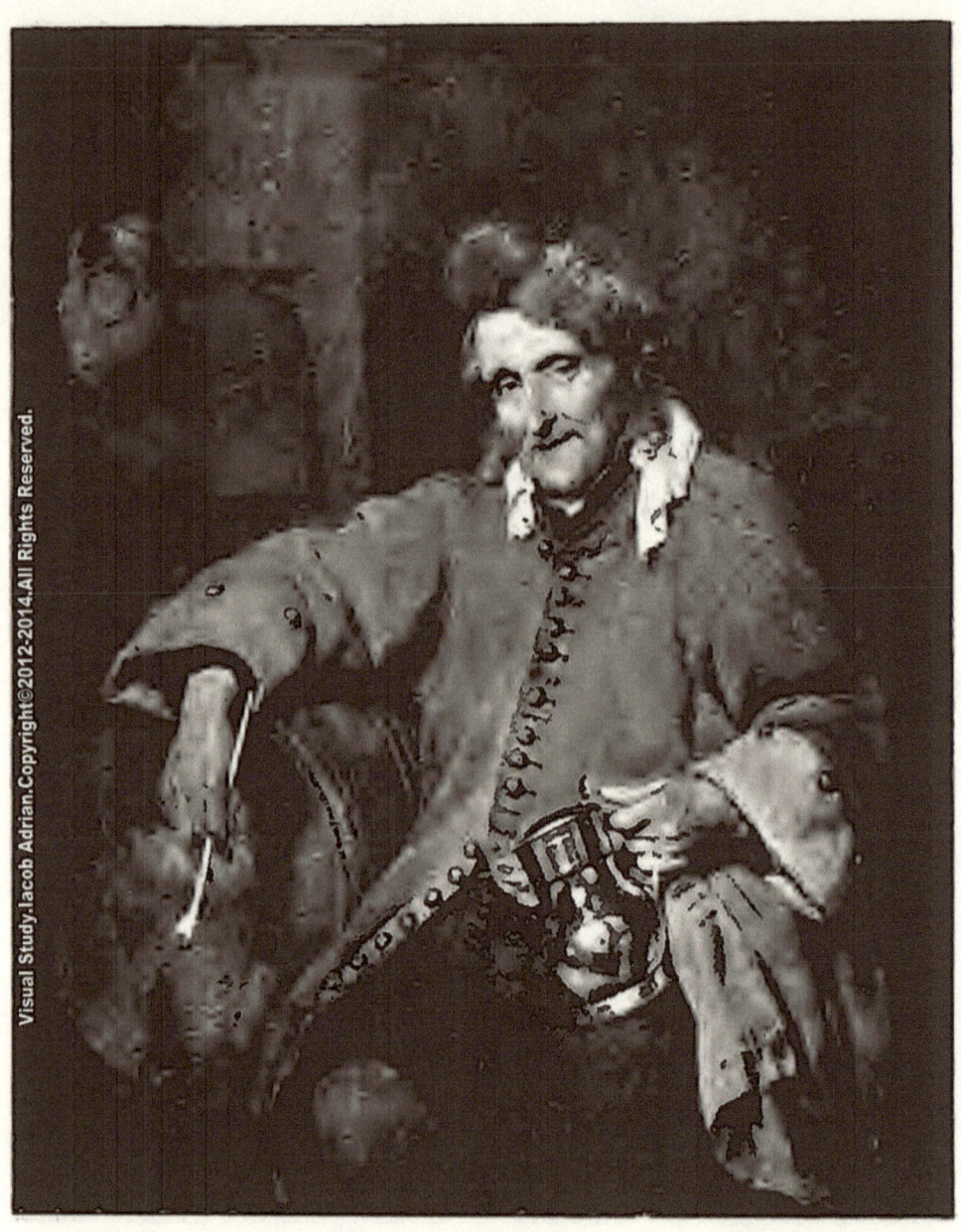

THE OLD TOPER [193] LE VIEUX BUVEUR
DER ALTE TRINKER
(*Rijksmuseum, Amsterdam*)
Medici-Bruckmann, Photo.

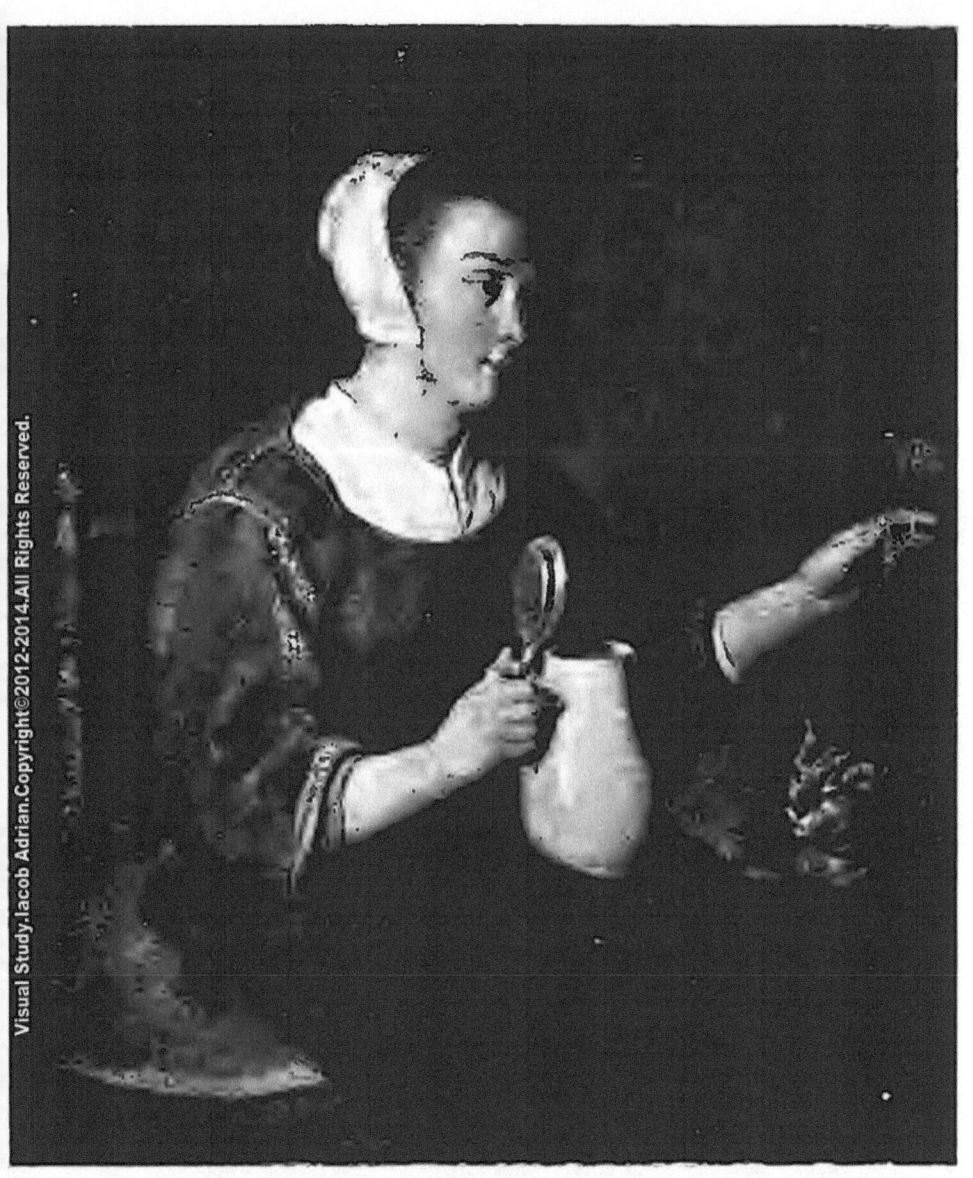

WOMAN WITH GLASS AND JUG [194] FEMME AVEC VERRE ET CRUCHE
(Gallery, Brunswick) (Galerie, Brunswick)
FRAU MIT GLAS UND KRUG
(Braunschweig, Galerie)
Medici-Bruckmann, Photo.

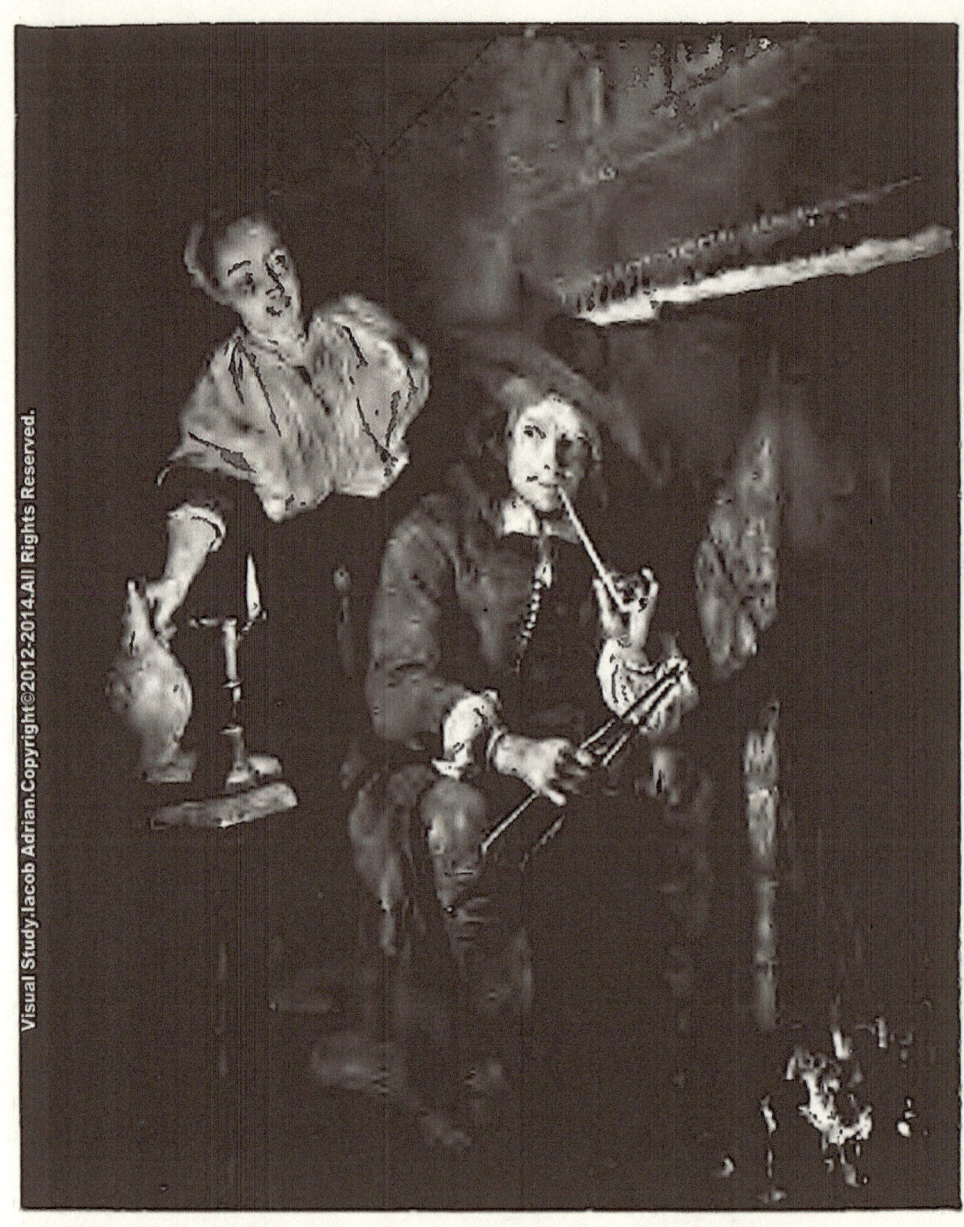

THE SMOKER AT THE FIRESIDE [195] LE FUMEUR AU COIN DU FEU
DER RAUCHER AM KAMIN
(Dresden, Galerie)
F. Hanfstaengl, Photo.

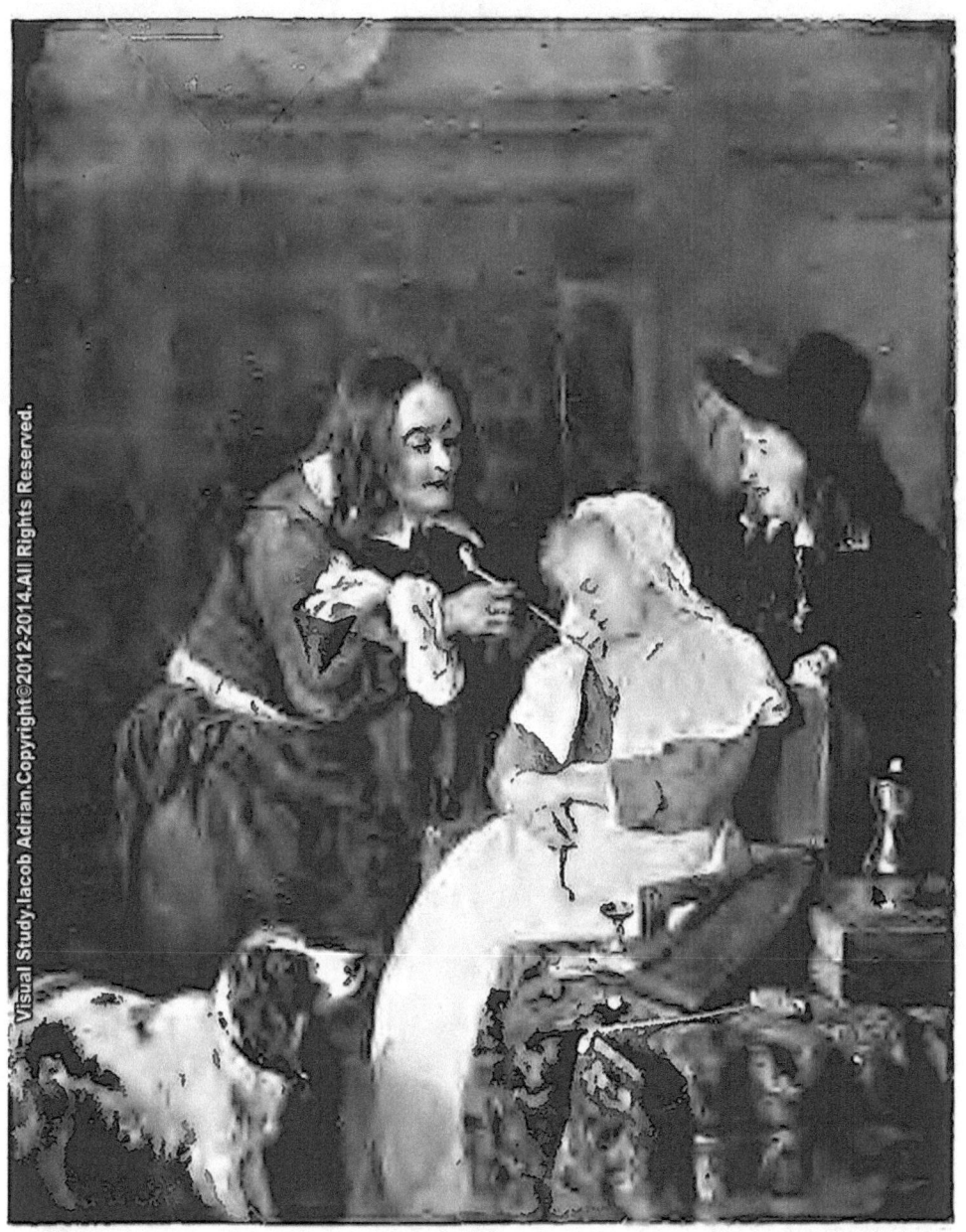

THE DROWSY LANDLADY [197] L'HÔTESSE ASSOUPIE
DIE SCHLÄFRIGE WIRTIN
(*National Gallery, London*)
F. Hanfstaengl, Photo.

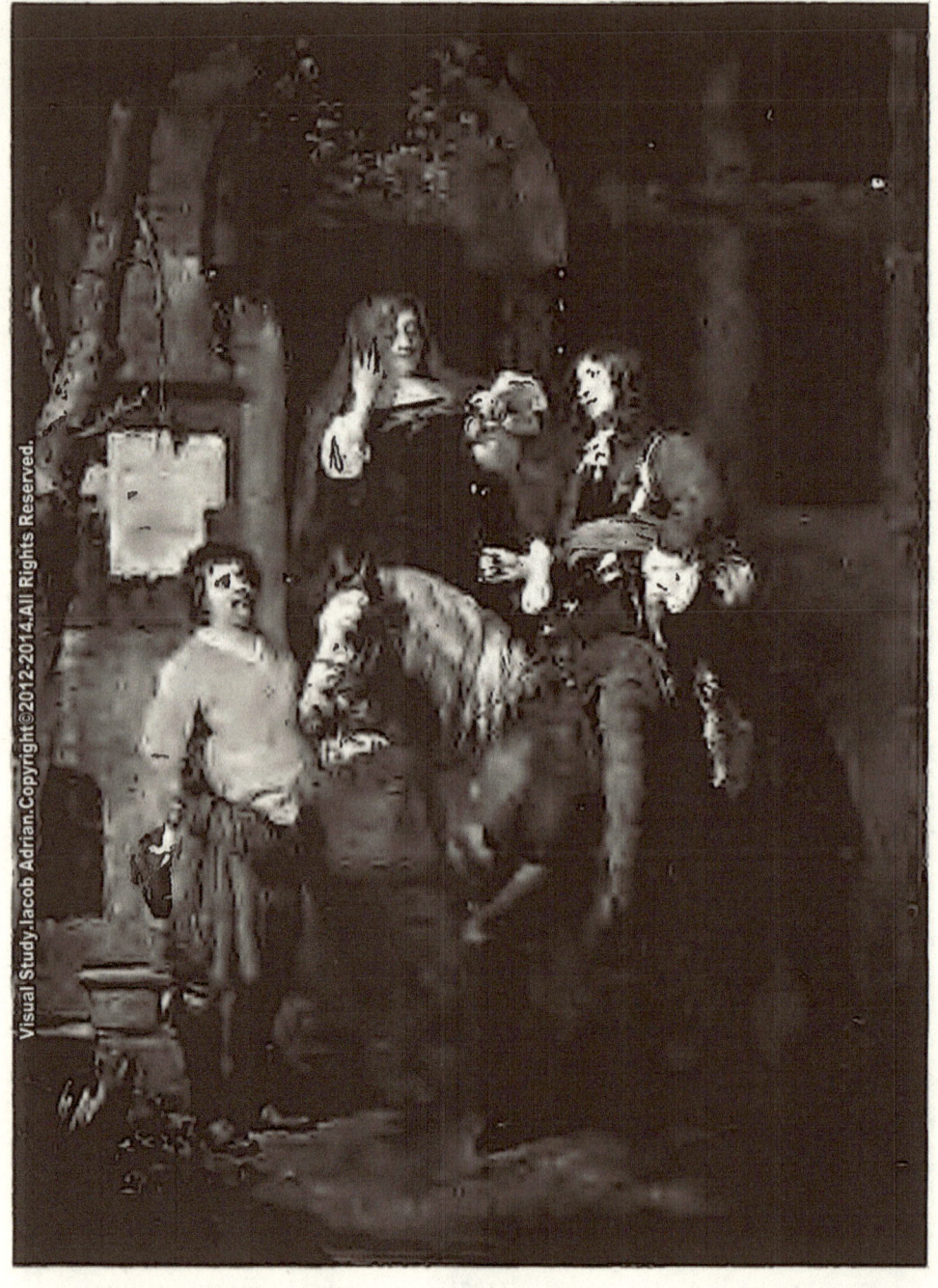

[198]

RIDER BEFORE INN CAVALIER DEVANT UNE AUBERGE
REITER VOR EINEM WIRTSHAUS
(Earl of Ellesmere, London)
Walter L. Bourke, Photo.

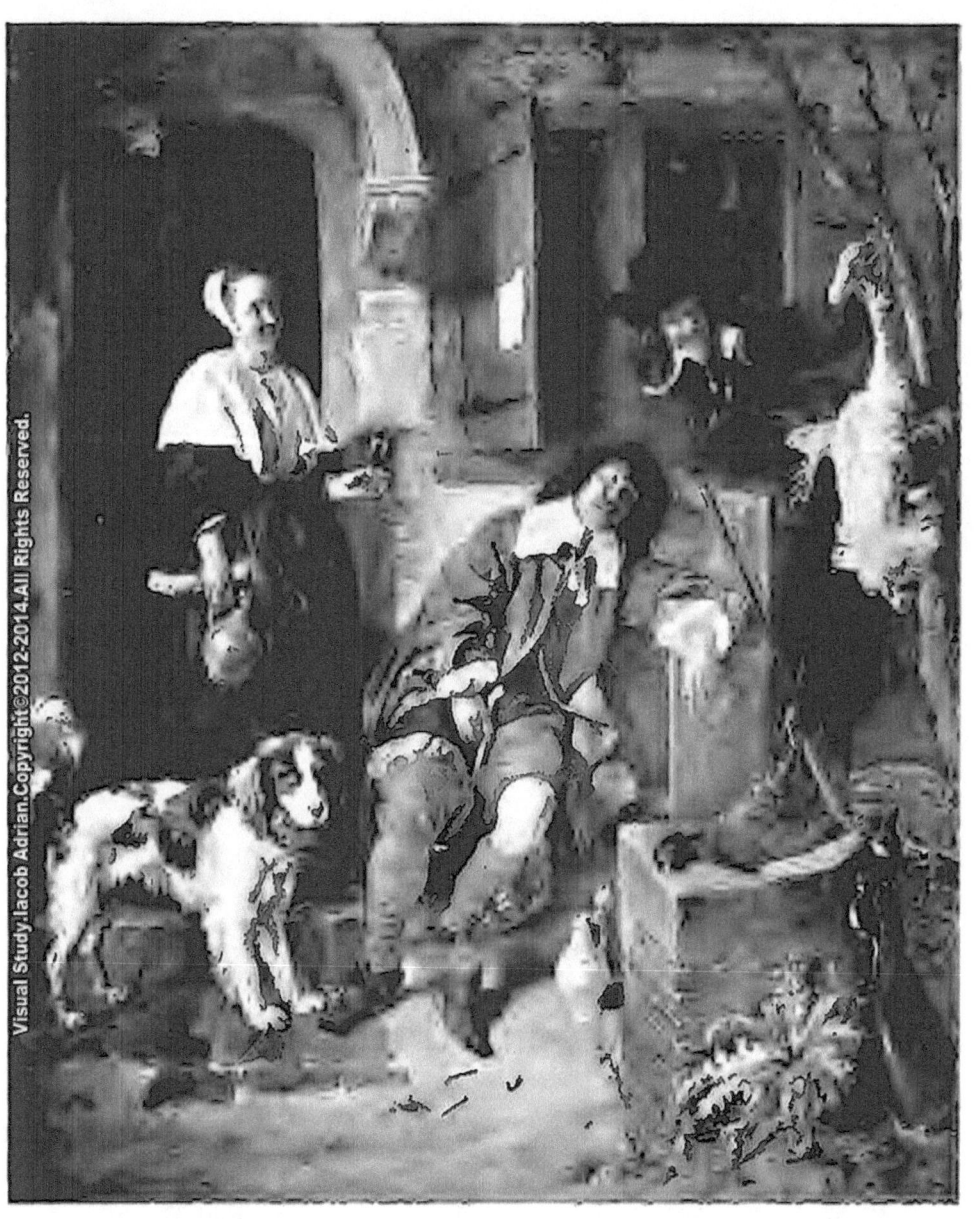

[199]
THE SLEEPING SPORTSMAN LE CHASSEUR SOMMEILLANT
DER SCHLAFENDE JÄGER
(*Wallace Collection, London*)
W. A. Mansell & Co., Photo.

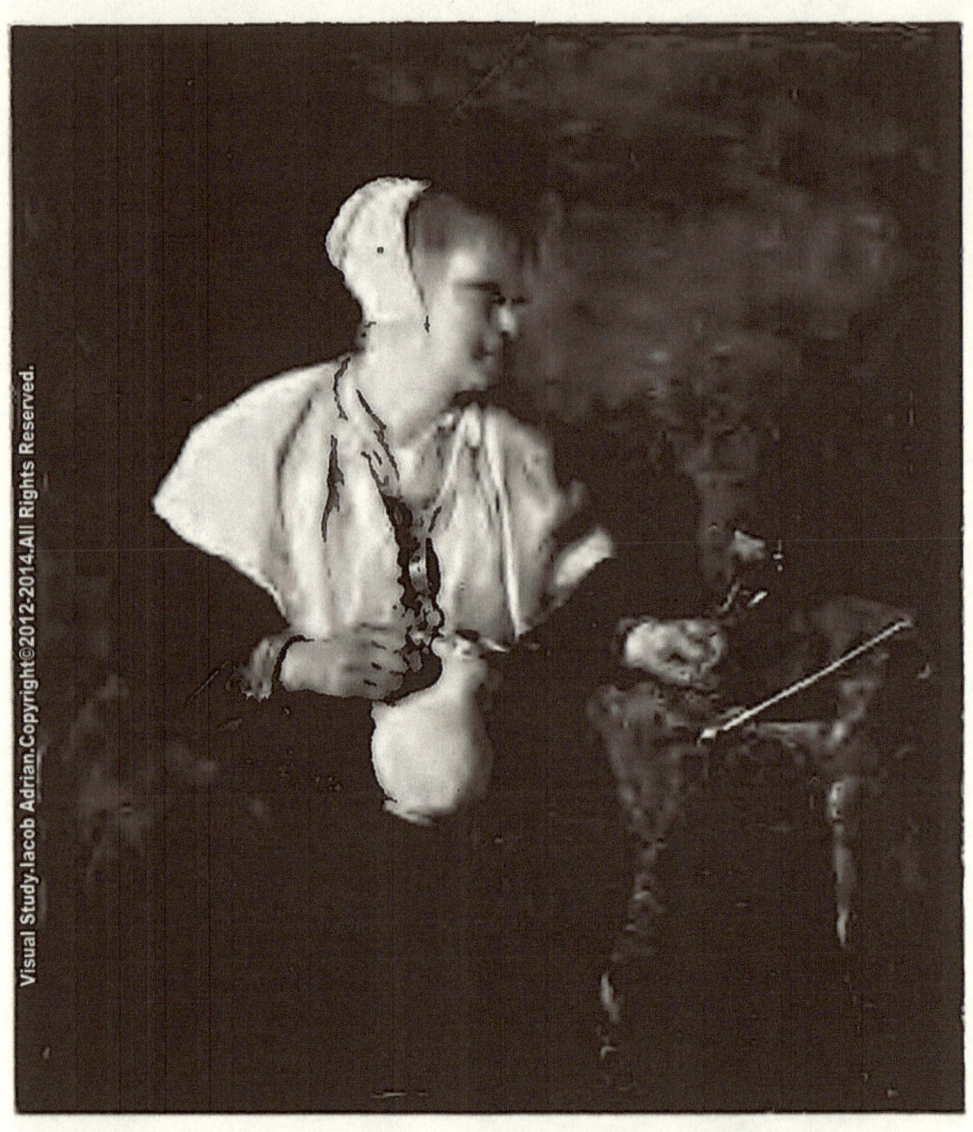

WOMAN WITH GLASS AND JUG [200] FEMME AVEC VERRE ET CRUCHE
FRAU MIT GLAS UND KRUG
(*Louvre, Paris*)
Neurdein Frères, Photo.

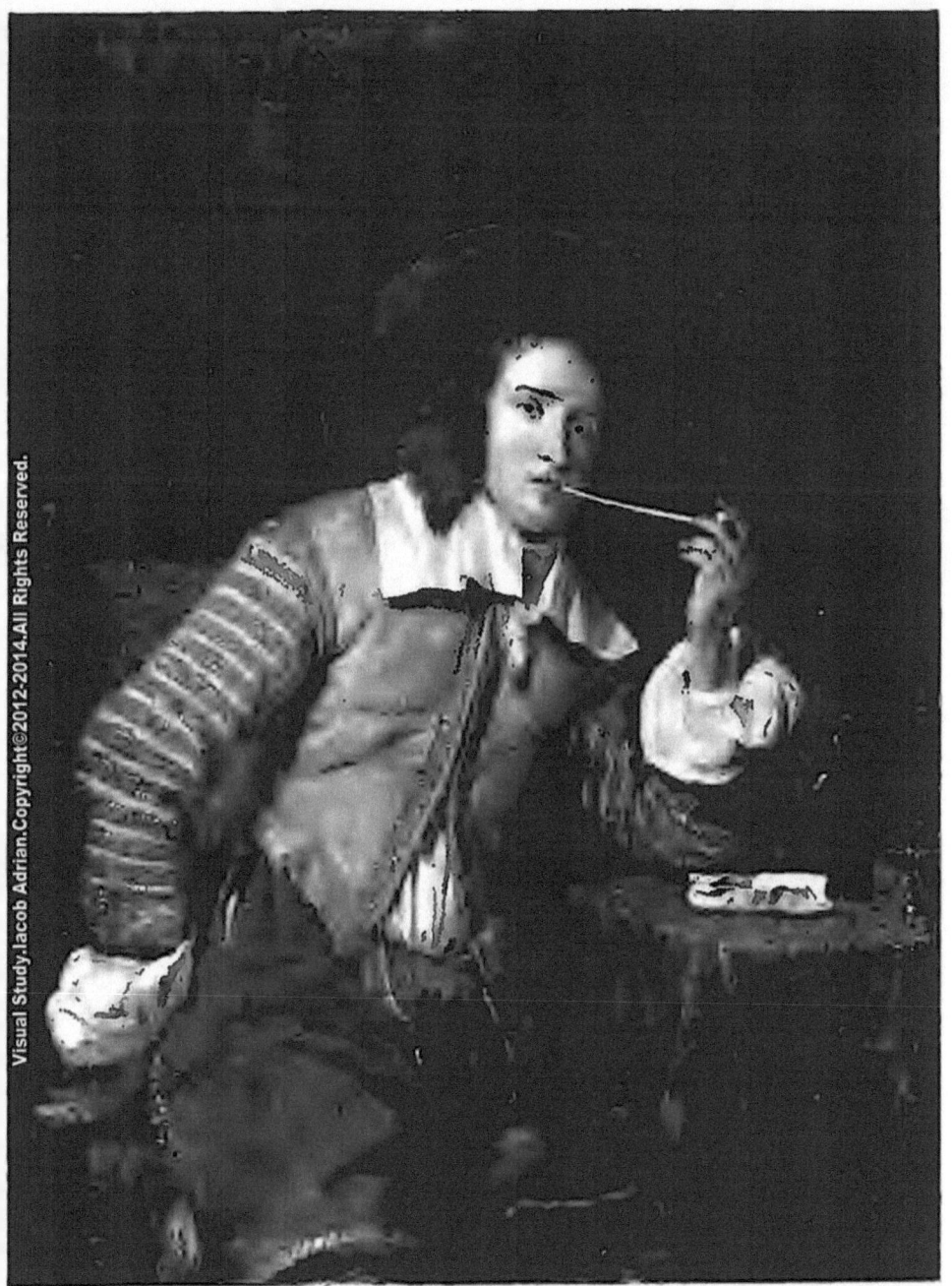

CAVALIER SMOKING [203] CAVALIER FUMANT
(Czernin Gallery, Vienna) (Galerie Czernin, Vienne)
RAUCHENDER KAVALIER
(Wien, Galerie Czernin)
J. Löwy, Photo.

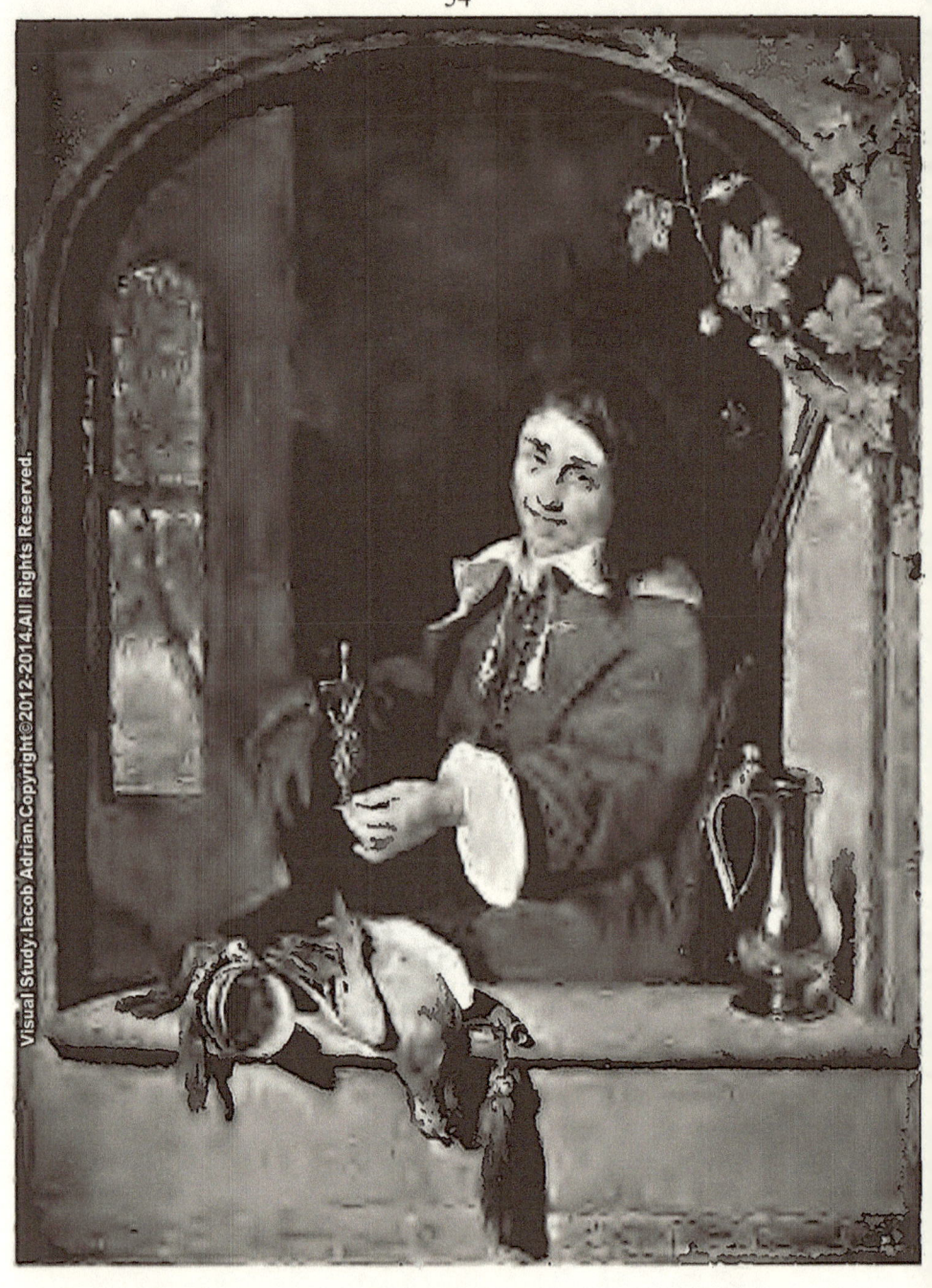

THE SPORTSMAN [207] LE CHASSEUR
(*Royal Gallery, The Hague*) (*Galerie royale, La Haye*)
DER JÄGER
(*Haag, Kgl. Galerie*)
F. Hanfstaengl, Photo.

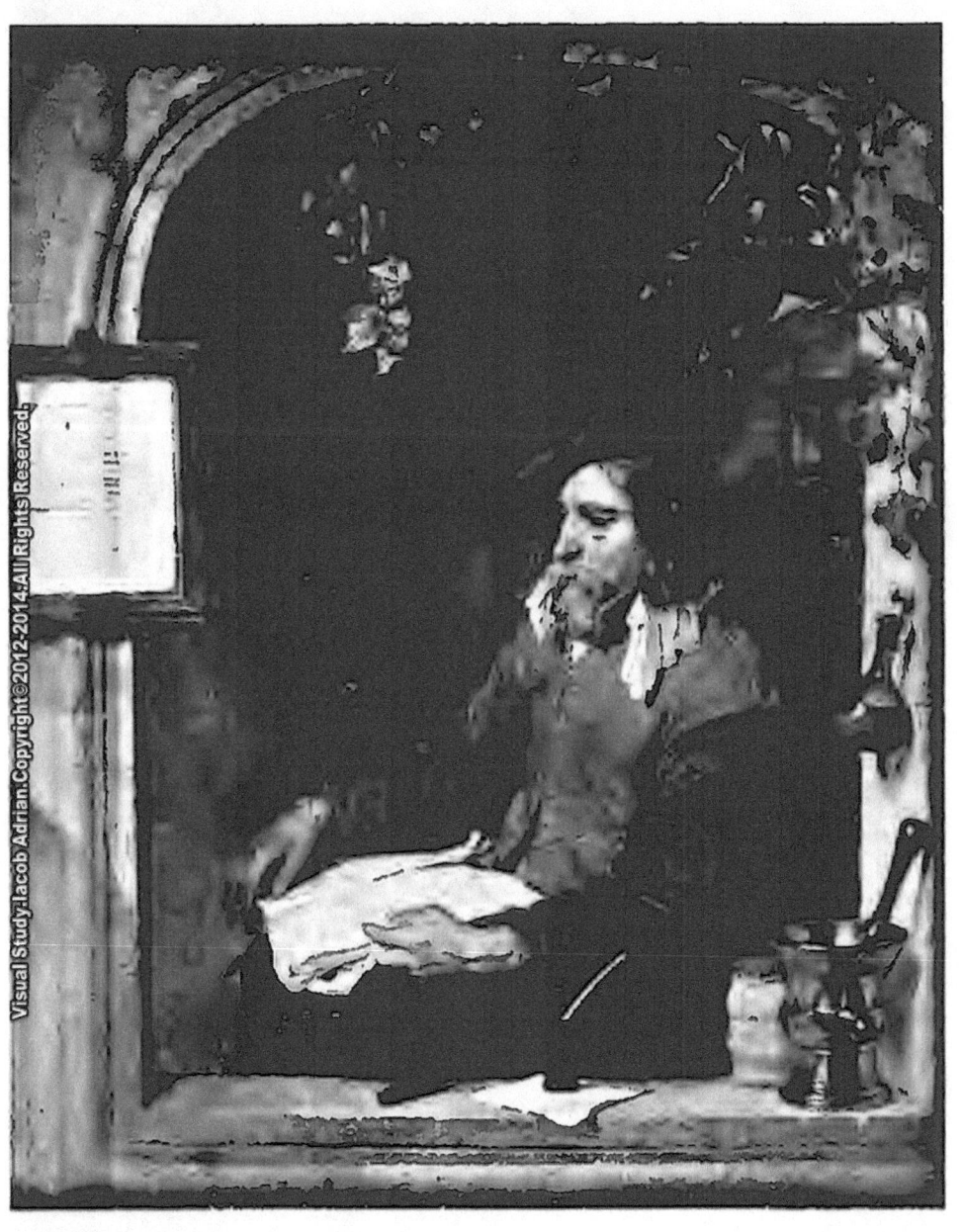

[209]
THE ALCHEMIST DER ALCHIMIST L'ALCHIMISTE
(*Louvre, Paris*)
W. A. Mansell & Co., Photo.

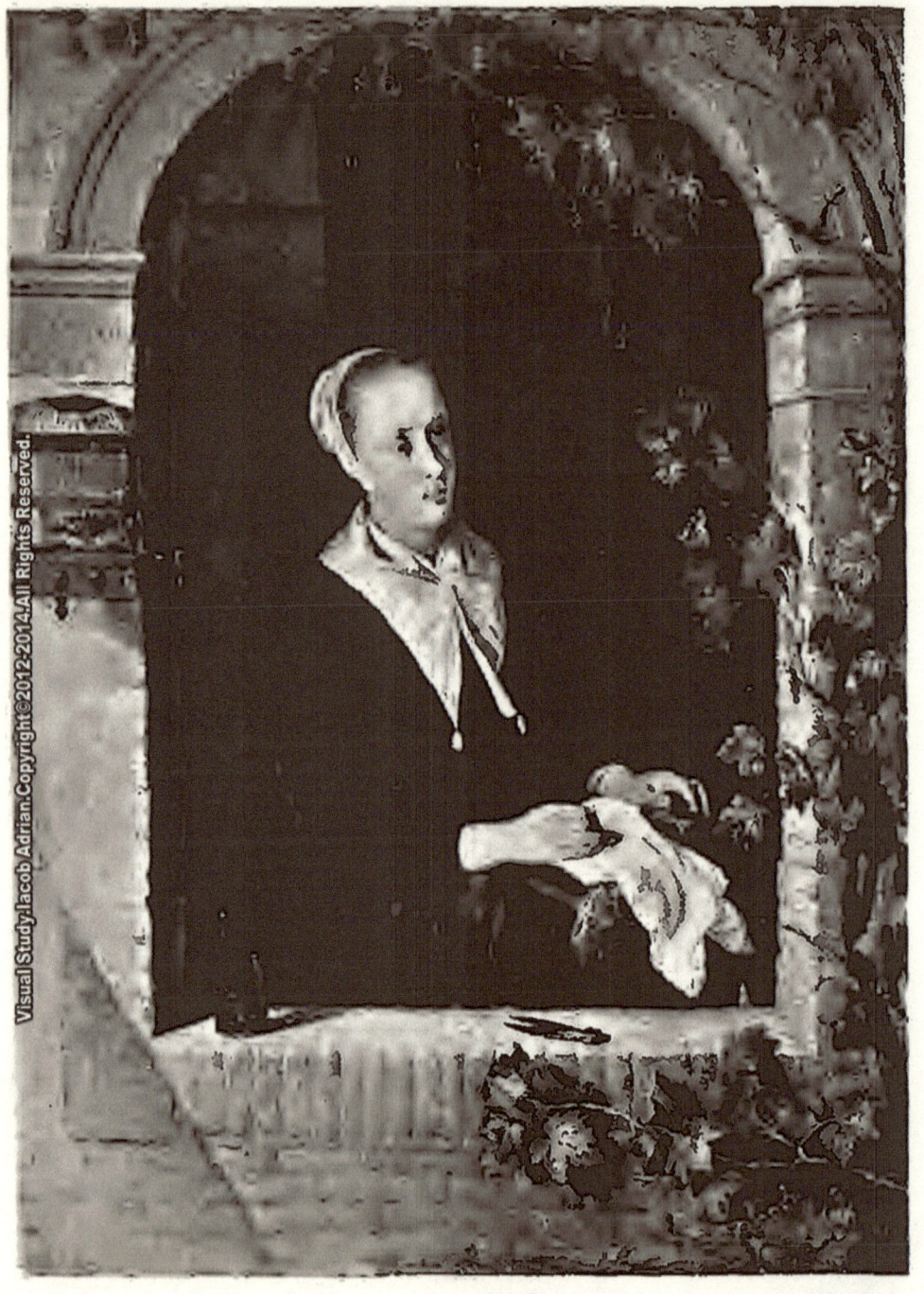

[214]
THE SEMPSTRESS DIE NÄHERIN LA COUTURIÈRE
(*Hermitage, St. Petersburg*)
F. Hanfstaengl, Photo.

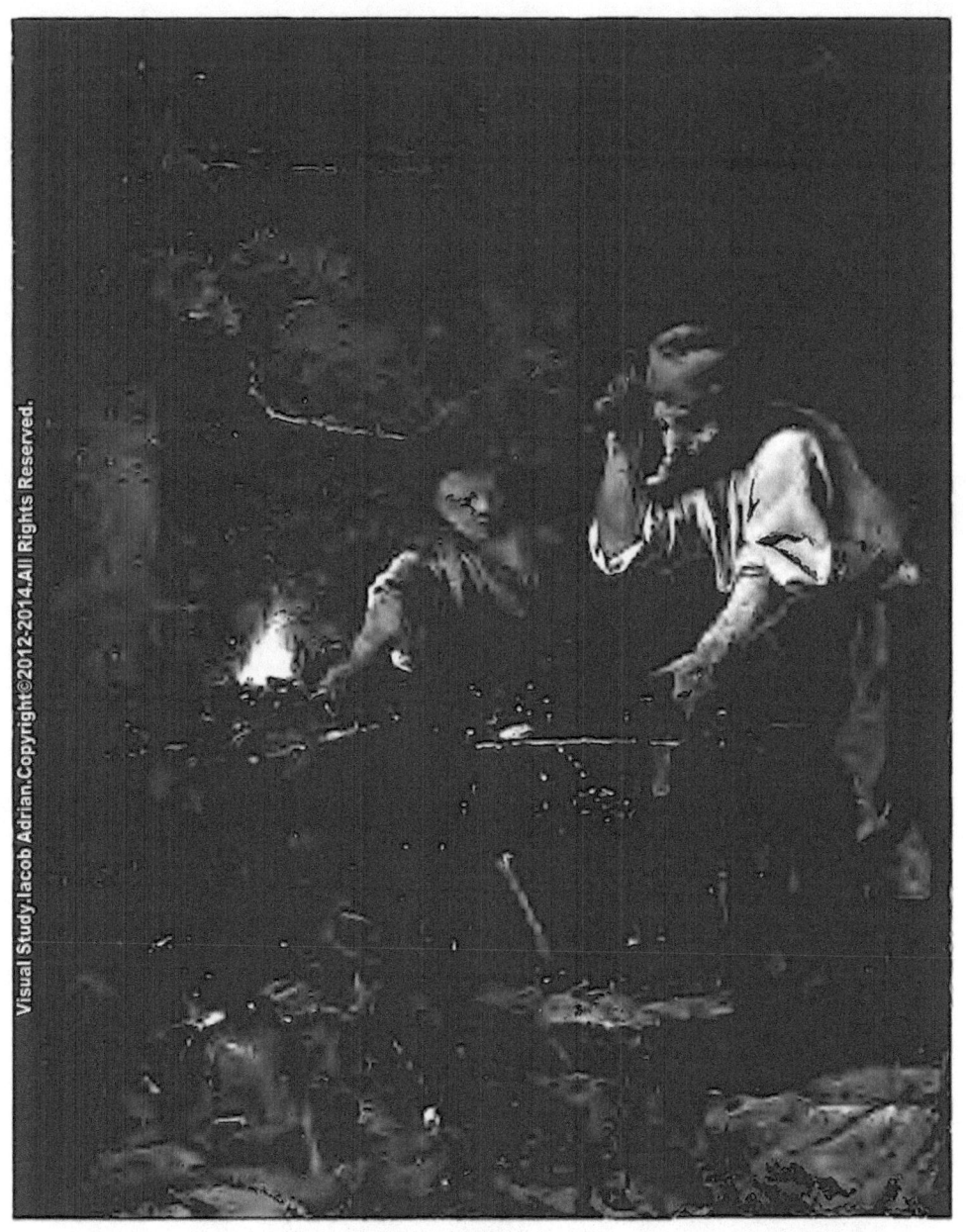

THE BLACKSMITH'S SHOP [219] L'ATELIER DU FORGERON
DIE SCHMIEDEWERKSTATT
(*Rijksmuseum, Amsterdam*)
Medici-Bruckmann, Photo.

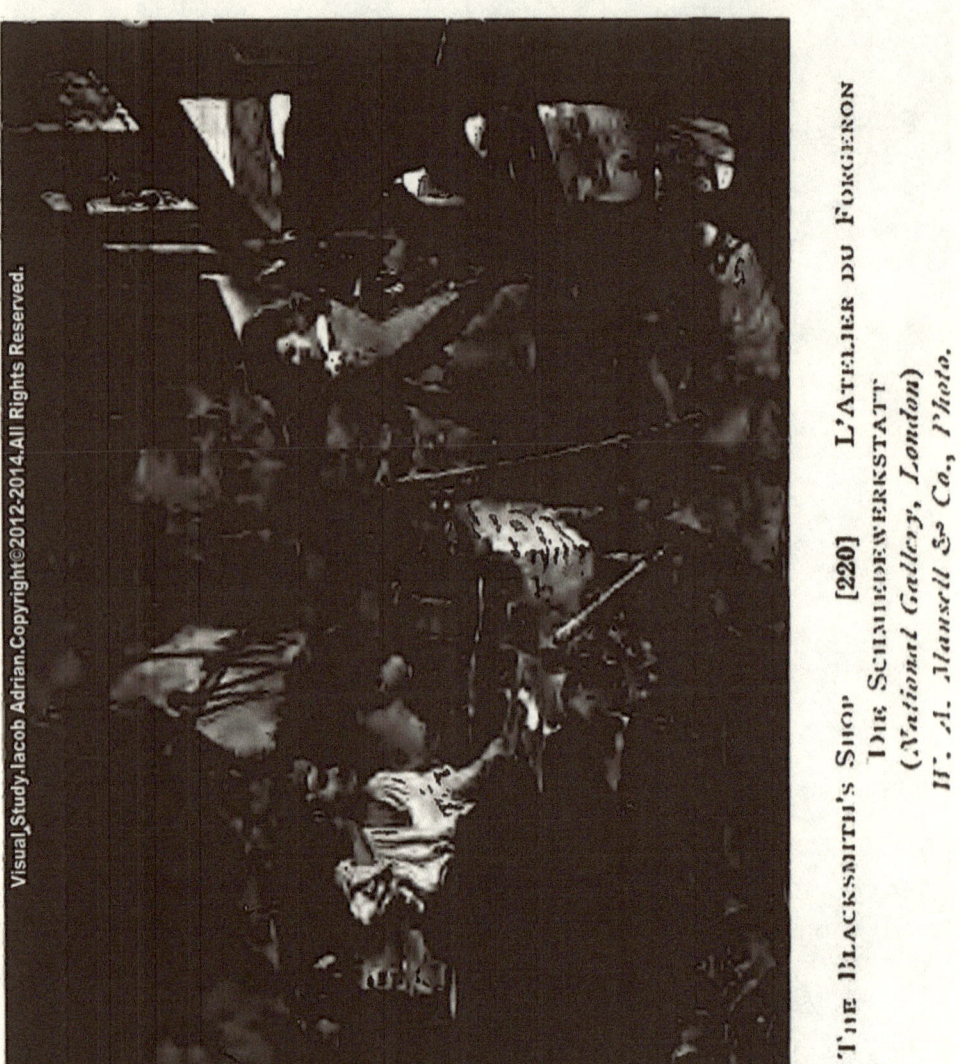

THE BLACKSMITH'S SHOP [220] L'ATELIER DU FORGERON
DIE SCHMIEDEWERKSTATT
(*National Gallery, London*)
W. A. Mansell & Co., Photo.

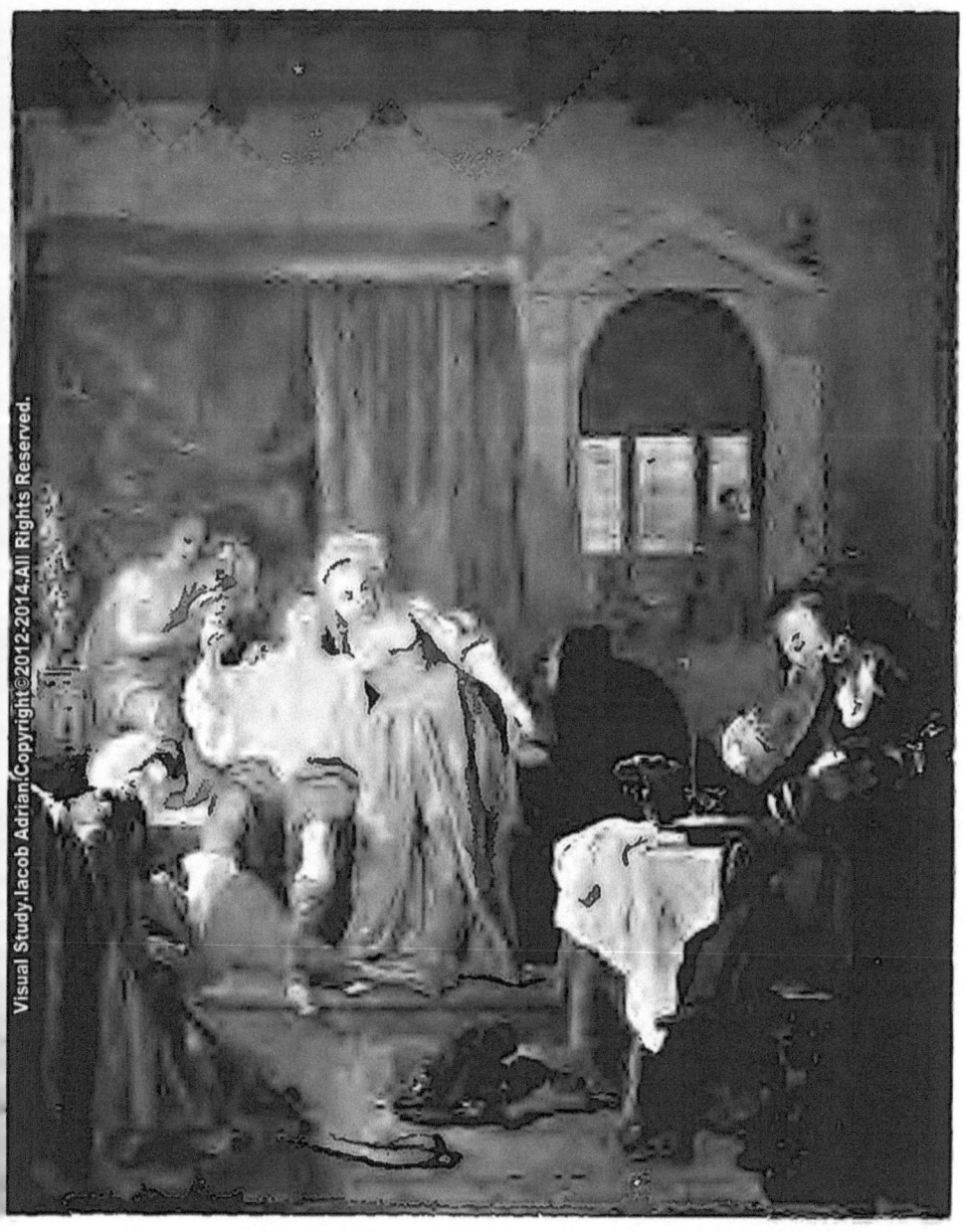

THE PRODIGAL SON [187] L'ENFANT PRODIGUE
DER VERLORENE SOHN
(*Hermitage, St. Petersburg*)
F. Hanfstaengl, Photo.

Bibliographic sources :

The masterpieces of Metsu (1630 (?) -1667) : sixty reproductions of photographs from the original paintings, affording examples of the different characteristics of the artist's work (1912)

Author: Metsu, Gabriel, 1629-1669

Publisher: London ; Glasgow : Gowans & Gray, Ltd.

This documentary study use,
combined in various proportions,
elements from the following categories,
forms and subsets :
- fair use
- documentary
- documentary photography
- feature
- journalism
- arts journalism
- visual journalism
- photojournalism
- celebrity photography
in order to :
- employ material as the object of cultural critique ,
- quote to illustrate an argument or point ,
- use material in historical sequence,
providing independent opinion,
using photos, press articles, advertisements,
opinions of fans etc. ...

Copyright©2012-2014 Iacob Adrian
All Rights Reserved.

www.ingramcontent.com/pod-product-compliance
Lightning Source LLC
Chambersburg PA
CBHW021022180526
45163CB00005B/2069